# WITHOUT MODEL

THE GERMAN LIST

# Theodor W. Adorno

## WITHOUT MODEL

### Parva Aesthetica

Translated by Wieland Hoban

LONDON CALCUTTA NEW YORK

This publication has been supported
by a grant from the Goethe-Institut

Seagull Books, 2023

Published in German as *Ohne Leitbild: Parva Aesthetica*
in Theodor W. Adorno, *Gesammelte Schriften in 20 Bänden*
© Suhrkamp Verlag, Frankfurt am Main, 1977
All rights reserved by and controlled through Suhrkamp Verlag Berlin

First published in English translation by Seagull Books, 2023
English translation © Wieland Hoban, 2023

ISBN   978 1 80309 218 8

British Library Cataloguing-in-Publication Data
A catalogue record for this book is available from the British Library

Typeset by Seagull Books, Calcutta, India
Printed and bound by WordsWorth India, New Delhi, India

# Contents

Without Model: In Place of a Preface • 1

Amorbach • 13

On Tradition • 22

Scribbled at the Jeu de Paume • 34

From Sils Maria • 40

Non-Conciliatory Proposal • 44

The Culture Industry: A Résumé • 51

Obituary for an Organizer • 61

Transparencies on Film • 68

Chaplin Times Two • 78

Theses on the Sociology of Art • 83

Functionalism Today • 92

Luccan Memorial • 115

The Misused Baroque • 120

Vienna, after Easter 1967 • 144

Art and the Arts • 154

*Bibliography* • 177

# Without Model

## In Place of a Preface

When I was invited by RIAS[1] to speak about current aesthetic norms and models, I declared myself unsuitable to adopt and positively apply such a concept as the model. The formulation of any kind of universal-normative, invariant aesthetics today strikes me as imposs-ible. It would only be possible for me to address the issue on the con-dition that I could express this position. The management of the radio university was liberal enough to make this concession. So I am neither willing nor able to conjure models on the wall like a speed painter or, in keeping with the still-widespread ontological trend, to waffle something more or less veiled about eternal artistic values. I can only discuss models and norms, in suitably fragmentary terms, as a *problem*. I find myself in a similar situation to that articulated in a famous text from philosophical history: 'What is to be done *immediately* at a given, exact moment in the future depends entirely on the historical circumstances. The question [ . . . ] exists in the land of mist; it is actually a phantom problem to which the only answer must be a critique of the question itself.'[2]

---

1 RIAS (Radio in the American Sector) was a radio and television station set up in the American Sector of Berlin by the US occupying authorities in 1946. [Trans.]

2 Karl Marx, Letter to Ferdinand Domela Nieuwenhuis (22 February 1881) in *On Revolution* (New York: McGraw-Hill, 1971), p. 66.

The word 'model' [*Leitbild*],³ with its quietly military tone, probably only became popular in Germany after the Second World War. It is at home in the domain of a conservative-restorative cultural critique on both sides of the East German border that draws on motifs from earlier German Romanticism, especially the work of Novalis and Schlegel. It usually rests on a negative reaction to contemporary art, which is viewed as ruptured, dominated by arbitrary subjectivity, repugnant, incomprehensible and walled up in its ivory tower. The form taken by modern art in all its manifestations, as a consequence of its objective development, is blamed on its producers as the result of a mindset that is esoteric, foreign to the people and possibly rootless; at best, it is attributed to their lamentable fate. Even if such thinking sometimes employs more humane terminology in the West, its affinity with the mindset common under both varieties of totalitarian systems is unmistakable. It operates with a form of vulgar sociology. Earlier societies, such as feudal or early bourgeois-absolutist society, were unified, whereas our open modern society dispenses with any binding laws. Here, unity is equated with what gives meaning and is positive; in former times, each work of art had its place, its function and legitimation, whereas now it is damned to arbitrariness and is therefore worthless. If art is to be possible as something objectively valid, it supposedly needs a firm framework that provides it with a canon of what is right and wrong. Since society no longer provides such a framework, however, what is demanded—in the absence of a totalitarian decree—is that one should at least establish an intellectual order, though some like to claim that it is not a matter of erecting it as discovering it within Being itself. Its purpose is to bring about what, in a state of blissful naiveté, the fabric of society and of the spirit have guaranteed. The question of aesthetic norms and models arises when permission and

---

3 The most literal translation of *Leitbild* would be 'guiding image'. [Trans.]

prohibition are no longer relatively uncontested, yet one still cannot do without their givenness—or, as Americans are wont to say, without a 'frame of reference'.[4]

I have simplified this type of reasoning in order to sharpen the question. But the structure of the cultural critique that deals with the concept of the model indeed remains fairly close to the plainness of those reflections. It is not the plainness of great simplicity, of old truth, to which they lay claim, but rather that of the *terrible simplificateur* which has meanwhile become so overused. As plausible as the claims sound, as confidently as they appeal to those who feel excluded by the new art and are enraged by what it utters, which they are unwilling to admit to themselves—everything about it is false. The social unity whose loss they mourn for the sake of art was heteronomous; it was largely forced on people. It came to an end not through some historical Fall of Man, nor through a fateful loss of the so-called centre. Rather, the constraints craved by so many today had become unbearable, for the intellectual substance by which it justified itself, and which was glorified on account of its binding nature, was revealed by the advancement of knowledge as neither true nor binding. If people are already ashamed of their enthusiasm for the Middle Ages (which was common a hundred and fifty years ago) because they realize the impotence of such fervour, the impossibility of returning humanity to a pre-bourgeois stage, then they can certainly not proclaim an intellectual state that, without a social structure like that of the Middle Ages or the time of guilds, would lack any genuine basis—and would thus be truly rootless.

The argument that the roundness, unambiguousness and immediate clarity of the aesthetic quality of works from pre-bourgeois times make them superior to recent art can seduce people into believing in warmed-up eternal values. The qualitative primacy of the works from

---

4 Adorno uses the English phrase. [Trans.]

those supposedly meaning-filled times is questionable, however. What shattered their order was not an abstract change in the course of events or 'style of thinking', but rather critical necessity. What distinguishes Bach from predecessors such as Schütz or Johann Kaspar Fischer is not only the zeitgeist of incipient subjective attunement, but equally the stringent awareness of the predecessors' inadequacy. A Bach fugue, as a fugue, is first of all better, more cohesive, more internally structured and more consistent than the rudimentary creations of the seventeenth century; painters required great effort to learn spatial perspective. In the disreputable nineteenth century, people still dared to utter such things rather than claiming it to be self-evident that naive, less self-aware art had greater dignity. Gottfried Keller's polemic against the anachronistic epic poet Jeremias Gotthelf is a great document of such intellectual ingenuousness and moral courage. Today, however, historicism, that highly un-naive education, spreads such terror that no one dares any longer to declare dull-minded, unemancipated products insufficient for those very qualities, unless they are exempted owing to an earliness whose sanctity can often be attributed to a less advanced state of productive forces, not to the breath of the first day of creation. The more un-naive the aesthetic consciousness, the greater the demand for naiveté.

Here one often finds that the unity of the style to which the creations belong, the way it is channelled through traditional procedures, is equated with its own quality; it is overlooked that the aesthetic quality is the result of the specific demands of the individual creation and the overarching unity of the style to which it belongs. This channelling through the style, the well-worn paths that can be followed without all too much effort, is mistaken for the matter itself, the realization of its specific objectivity. Great art has barely ever restricted itself to a congruence between the individual creation and its style; to the same degree, the style is created by the

individual creation through the manner of its contact with the style. There is reason to suppose that for past works too, the most significant creations are those in which the subject and its expression are precisely not in the state of unchallenged unity with the whole that is suggested by stylistic conformity. Only on the surface do the great works of the past seem fully unified and simply identical to their own language. In reality, they are force fields in which the conflict between the decreed norm and that which seeks utterance within them is waged. The higher their level, the more energetically they wrestle out this conflict, often dispensing with the affirmative artistic success that is celebrated. While it is true that the great art works of the past were not possible without style, they were at once against style. Style simultaneously fed and shackled productive forces. If dissonance steps decisively into the foreground in contemporary music and ultimately does away with consonance, and thus with the very concept of dissonance, one could show that composers have been tempted by dissonance for many centuries as a possibility to voice suppressed subjectivity, suffering imposed by unfreedom and the truth about the prevailing ills. The highest moments were those in which the dissonant element won out, yet was still subsumed under the equilibrium of the whole: both the inner historiography of negativity and the anticipatory image of recon-ciliation. While contemporary painting sheds its last similarity with representationalism, the most significant pictures and sculptures of the past were forced a priori to adopt an unreserved similarity with the world of objects by the constraints of clients or the market. They were driven beyond this by the force of the work, just as musicians were driven beyond the ideal of euphony: at the risk of repeating the all-too-familiar, I will name two painters who were at home in the theological domain: Grünewald and El Greco. The implications of Valéry's statement that in art, the best of the new always meets an old need, are inestimably far-reaching. It not only explains the more obvious stirrings of the

new that are denigrated as mere experiments, a necessary answer to unsolved questions, but also destroys the ideological semblance of blissful security that past works often assume only because the old suffering can no longer be immediately read in them as a cipher for suffering in the present world.

Because their underlying premises have disappeared, past norms can no longer be upheld; taking them as reference points would be as arbitrary as the state that cultural conservatism all too readily condemns as anarchic. The norms whose former legitimation has now itself been called into question were only made meaningful by what Hegel called substantiality: the fact that they were not set apart from life and consciousness as something intrinsically posited from without, but rather, for all that was questionable, existed in a certain unity with life and spirit. Without such substantiality, without the same spirit manifesting itself in the norms that it follows, it is futile to chase norms and models. It is no coincidence that people reach into the past. They sense that substantial norms are lacking, and that to proclaim them would necessarily be an act of wilfulness, and thus dubious; in the past, however, they feel there is substantiality. What is overlooked, however, is that the process which wiped out those norms is irreversible. The spirit, as Hegel says, is not capable of clinging to past worldviews for the sake of art and appropriating their substance. The overall critical movement of nominalism, which destroyed the abstract primacy of the concept over that to which it specifically refers, cannot be extinguished in the aesthetic domain any more than in metaphysics or epistemology. The longing for this, which is suspicious enough as a need for a clear position and order, does not guarantee the truth or objectivity of its aim. Nietzsche's insight that the justification of substance with the need to have it is an argument against rather than for it, is as accurate today as it was 80 years ago.

This need has undeniably increased; at least, those who call themselves positive incessantly seek to hammer it into people. But critique would have to get to the heart of that need as well as the situation from which it arises, and to which it is seemingly in opposition. Both are really the same thing: a reified consciousness. Historical movement has torn asunder the dominant form of reason, as an end in itself, and its object, as the mere material of that reason. It thus undermined the idea of objectivity and truth, which it had been the first to formulate, at the same time; their fall then became the suffering of reflection. Yet the frozen antithesis of subject and object continues in an attitude that imagines norms in an abstract, separate and objectified form—like herrings hanging down from the ceiling for the hungry to snatch. They are contrasted in so external and alienated a manner with their own consciousness, not experienced as its own concern any more than is the overpowering world of objects of the present state, to whose dictates people submit without objections, as if they were powerless. The word 'values', which has become fashionable since Nietzsche to refer to insubstantial norms that are divorced from humans, and which was not by chance taken from the sphere of objects par excellence, namely that of economic exchange, points better than any critique to what the call for models is really about. If one cries out for them, they have already become impossible; if one proclaims them out of a desperate wish, they are bewitched into blind and heteronomous forces that only reinforce helplessness, and thus correspond to the totalitarian mentality. The norms and models that are meant to help people in a fixed, immutable way in the orientation of an intellectual or artistic production, whose innermost principle is actually freedom, merely reflect a weakness of the self in relation to circumstances they feel powerless to influence and the blind power of what is simply the case. Those who confront the so-called chaos of today with a cosmos of values only show how much this chaos has already become the

law governing their own actions and imagination. They fail to recognize that if artistic norms and criteria are truly to be more than labels indicating the correct mindset, they precisely cannot be hypostatized as something finished, something valid beyond the realm of living experience. For art, there are no norms but those which are moulded in the logic of their own movement, and can be filled by a consciousness that respects, produces and in turn changes them. Yet only very few are still willing and able to attain this achievement, which has been made prohibitively difficult by the collapse of all predefined expressive languages. What makes the unified majority that lectures them about models and norms so comfortable is that it can effortlessly propagate the path of least resistance as that of a higher ethos, of rootedness and perhaps even existential dignity.

Fixed norms would merely be prescriptions today, and therefore not binding—even where they are met with obedience. Any art that complied with them would be nothing but compliant, amounting to a pastiche or copy. Most find it difficult to recognize a crucial fact, namely that art does not descend into relativity by uncompromisingly rejecting the static and abstract norm of artistic production. Insisting on this is so problematic because it brings one closer to those who, to avoid making themselves unpopular with their criticism at all costs, add dutifully that they do not mean it as harshly as all that, and furtively smuggle in through the back door what they chased out through the front door. Even those of us who are alertly suspicious of this habit, however, must not evade the fact that the force betrayed through the formation of models consists precisely in distinguishing between right and wrong, true and untrue, unsupported by anything false and based purely on the matter itself. A renunciation thereof, which abandons aesthetic seriousness and overtly surrenders its procedures to the same arbitrariness that covertly drives the formation of models, is just as feeble as an authority-bound mentality in art. An understanding of the concrete

laws of the works that are emancipated from general prescriptions must not, however, harden anew into a catalogue of what is forbidden and allowed. I once compared artistic production and the process of appropriately understanding it to the ill-reputed miner without a light, who does not see where his path is leading, yet whose sense of touch precisely reveals the texture of the tunnels, the hardness of the resistance, the slippery spots and the dangerous edges, and thus guides his steps and does not abandon them to chance. If, however, one concluded from this that any deeper insight into the right and wrong of contemporary art were taboo, and that it were purely a matter of obeying—in literal blindness—the context of each individual conception, then this would be an overly hasty resignation of the idea before the darkness of the aesthetic gestalt. Because the nature of those things which convey themselves to the artist's sensorium and have yet to be realized must be elevated to self-critical awareness through reflection in order for anything humane to emerge, artistic production—for all the concrete immanence in the particular object—ultimately requires the concept. The hidden justification for this may lie in the fact that even in the most individual impulses of the art work, those incommensurable with any schemata imposed from without, certain objective principles survive that resemble those which sometimes characterized the manifest, objective formal language of art. The only possible answer to the need for norms—insofar it is not simple weakness, but rather, as weakness, points to a lack—would be for artistic production to yield, without in any way peering outside itself, and submit to the compulsion of its here and now, hoping that the consistency of such unconcealed individuation would prove the objectivity of that individuation; to reveal the particular, to which the work does full justice, as the universal.

In spite of all reservations, this should be articulated somewhat more generally. Every work of art today must be fully internally

structured and contain no dead spot, no heteronomously received form. Whether this is aimed for, or whether the work's approach no longer even respects the claim to the absolute that it makes through its very existence, determines its formal standard. In a situation where no stylistic language any longer elevates the mediocre, assuming it ever did, one can surely say that only works of the highest formal standard have a right to exist; the mediocre, which shies away from the effort of drafting minute details, has directly become the bad. How a work of art is to meet such rigorous criteria, however, depends not on some arbitrary, merely self-imposed rule that one decides to follow. However accurately Hans Sachs's advice to Walter Stolzing identifies the things being presented as norms and models today, it reveals little about the level of objectivity in the subjective approach. Rather, the bond that is futilely invoked on the basis of a worldview lies first of all in the material with which artists have to work. Recognizing this was the inestimable achievement of the movements that became known under the names of objectivity [*Sachlichkeit*] and functional form. However, history is sedimented in the material. Only those who can distinguish between the historically apposite and the irretrievably obsolete are capable of doing justice to the material in their production. Artists are aware of this whenever they avoid colours, forms or sounds that would be available as natural substances, but which, through historical associations, oppose the specific meaning of what they are meant to provide in that time and place. That the material does not consist of abstract, atomistic primal elements that lack any inherent intention and can thus be appropriated at will by artistic intentions, but rather brings its own intentions into the work, is merely another way of expressing this. The work can only take these intentions up into its own context if it understands them, stays close to them and thus modifies them. Artists do not paint with colours or compose with notes, but rather with relations between colours and notes. The

artistic concept of material would become impoverished and forfeit its objectivity if it wiped the slate clean and ignored the determinate character of the elements it uses.

But the sphere in which one can determine right and wrong, yet without recourse to deceptive models, is the technical one. This real-ization, incomparably formulated in Valéry's writings, should be borne in mind by all new art if it is truly to avoid sliding into harmful arbitrariness. One can only rise from the technical instructions of artistic education, which still follow external norms and procedures yet are capable of distinguishing quite precisely based on their crite-ria, to that understanding of technique which, beyond all such seem-ingly secured notions, shows how something should or should not be based purely on the complexion of the matter itself. If one counters that technique is purely a means and only the import[5] is the end, this is a half-truth like all hackneyed statements. For no import is present in art without being mediated in its appearance, and technique is the epitome of such mediation. Only in the imple-mentation of technical principles can one judge whether a work of art has sense or not; its sense can only be understood in the centres of its complexion, not as something simply meant or expressed by it.

Admittedly, the foremost issues would be the truth of such sense itself, the truth of the import and, finally, the question of whether the traditional concept of meaningful organization is even still adequate to what the art work demands today. The shadow of relativity this ultimately casts on aesthetic judgement is none other than the shadow of a conditionality that inheres in all human-made things. Drawing a false conclusion from such a radical question, however,

---

5 'Import' is a translation of *Gehalt*, which refers to the artistic substance arising from the interplay of form and content [*Inhalt*] within the historical context. Although both *Gehalt* and *Inhalt* can conventionally be translated as 'content', the latter usually denotes a thematic focus and clearly differs from what Adorno means by the former. [Trans.]

On the main road, around the corner from the beloved inn Zur Post, there was an open smithy with a dazzling fire. Every morning, I was woken very early by the resounding blows of the hammer. They never angered me; they brought me the echo of something long past. The smithy existed at least until the 1920s, when there were already petrol stations. In Amorbach, the primeval world of Siegfried, who in one account was slain at the Zittenfeld spring, deep in the wooded valley, protrudes into the pictorial world of childhood. The Heunesäulen, the sandstone pillars below Mainbullau, date back to the Migration Period, or so I was told, and were named after the Huns. This would be more appealing than if they originated from earlier, nameless times.

The ferry across the Main, which one must take in order to ascend to Engelberg Abbey, gains its particular expression from the fact that this archaic tool bears no trace of the deliberate preservation one finds in traditional costume societies or historical monuments. There is no simpler or more sober way to reach the other shore than the vehicle from which Hagen threw the chaplain into the Danube, the only one in the procession of the Nibelungs to be saved. The beauty of the functional has retroactive power; the sounds made by the ferry crossing the water, listened to in silence, speak to us so strongly because they were no different millennia ago.

In fact, I did come into contact with the sphere of Richard Wagner in Amorbach. There, in an annexe of the monastery, the painter Max Rossmann had his studio; we often went there for afternoon coffee on the terrace. Rossmann had made decorations for Bayreuth. It was he who truly rediscovered Amorbach and brought singers from the festival ensemble there. Something of the opulent lifestyle, with caviar and champagne, found its way into Zur Post, whose kitchen and cellars surpassed what one would have expected of a rural inn.

I recall one of the singers very clearly. Although I cannot have been more than ten years old, he gladly engaged in conversation with me once he noticed my passion for music and theatre. He untiringly regaled this whippersnapper with tales of his triumphs, especially in the role of Amfortas. He pronounced the first syllable in a strangely drawn-out way; he must have been a Dutchman. I felt I had been taken up simultaneously into the adult world and the dreamed world, not yet suspecting how irreconcilable they are. It is because of those days that to me those bars from *Die Meistersinger*, 'The bird that sang today had a well-formed beak', Rossmann's favourite passage, *are* Amorbach. The little town is only 80 kilometres from Frankfurt, but in Franconia. One painting by Rossmann, 'The Konfurt Mill', an unfinished work of imposing brokenness, captivated me. My mother gave it to me before I left Germany; it accompanied me to America and back. I met Rossmann's son when I returned to Amorbach.

Roaming the town's streets late in the evening as a solitary adolescent, I heard my own steps echoing on the cobblestones. I only recognized that sound when, after returning from American emigration in 1949, I walked through the Parisian night at two in the morning from the Quai Voltaire to my hotel. The difference between Amorbach and Paris is smaller than between Paris and New York. Yet that Amorbach twilight, which made me think as a small child that, sitting on a bench halfway up the Wolkmann, I was seeing the newly introduced electric light coming on in all the houses at once, anticipated the shock that later met me as an exile in America. My little town had sheltered me so well that it had even prepared me for its complete opposite.

When one arrives in America, all places look the same. The standardization, a product of technology and monopoly, is alarming. One supposes that the qualitative differences have disappeared from

grounds. At that moment a warden appeared and chased us away, informing us brusquely that the benches were reserved for the princely family.

As a schoolboy, I thought the words 'decent' and 'chaste' meant something highly unseemly, probably because they were mostly used in the context of indecent acts: less as praise than to refer to their own violation. They were connected to the forbidden realm, at any rate, albeit as its opposite. Amorbach augmented this misunderstanding with a powerful association. The bearded, dignified chief court gardener was called Keusch.[5] He had a daughter whom I found repulsively ugly; it was rumoured, however, that he had sexually abused her. As in an opera, it required the intervention of the kindly prince to crush the scandal. I was already fairly grown-up by the time I discovered my error in taking 'chaste' and 'decent' for unseemly words.

In the guest room at Zur Post, hanging on the wall next to the upright piano with the Mozart medallion, was a guitar. It was missing one or two strings, and the rest were very out of tune. I could not play the guitar, but strummed all the strings at once and let them resonate, intoxicated by the dark dissonance—probably the first with so many notes that I had encountered, years before I knew a note of Schoenberg. I felt that this was how one should compose, the way this guitar sounded. When I later read the line by Trakl, 'Sad guitars trickle', it was none other than the damaged one in Amorbach that I heard.

Not infrequently, at around 11 in the morning, a man entered Zur Post; he was half farmer, half merchant and came from Hambrunn,

---

5 *Keusch* means 'chaste'. [Trans.]

one of the neighbouring villages in the Odenwald forest built on the high plateaus. As he drank his beer, Herkert, with his little beard and wild clothing, seemed as if he had been catapulted there from the Peasants' War, of which I had learnt from reading the account of Gottfried von Berlichingen's life, which I had obtained as a little Reclam Verlag volume from the book vending machine at Miltenberg train station: *Miltenberg Is Burning*. There was so much still present in the area from the sixteenth century, traces of people and things, that it never occurred to me how long ago it was; spatial proximity became temporal proximity. But Herkert had a sack over his shoulder full of fresh nuts in their green outer shells; they were bought and opened for me. They kept their taste over time, as if the peasant leaders of the 1525 revolt had intended them for me out of sympathy, or to ease my fear of dangerous times ahead.

Sitting on Rossman's terrace one afternoon, I heard wildly roaring singing coming from the square in front of the castle mill. I espied three or four very young lads, indecorously dressed; it was meant to be picturesque. It was explained to me that they were wayfarers, though that meant very little to me. More than the ghastly folk songs, accompanied poorly with guitars to boot, I was startled by the sight of them. I fully realized that these were not paupers like those who slept on the park benches by the River Main in Frankfurt, but 'better people', as the childish expression goes. Their outfits resulted not from need, but from an intention that was opaque to me. They filled me with the fear that I would one day have to do the same, stomping through the woods noisily and unprotected: the threat of being downgraded in the youth movement, long before it became the place where downgraded citizens came together and went on grand tours.

If one read it in a novel, it would be unbearable in the same way as writers who try to sell quaintness as irrepressible humour. But I

# On Tradition

## 1

Tradition comes from *tradere*, 'to pass on'. It refers to the connection between generations, to what is inherited from one link to the next, and probably also to handing down crafts. The image of passing on expresses physical closeness and immediacy: one hand receives it from the other. Such immediacy is that of more or less primal relationships, such as familial ones. The category of tradition is essentially feudal, just as Sombart called the feudal economy traditionalistic. Tradition is at odds with rationality, even though the latter developed within the former. Its medium is not consciousness, but rather the predetermined, unconsidered obligation of social forms, the presence of the past; this has involuntarily been transferred to matters of the spirit. Tradition in the strict sense is irreconcilable with bourgeois society. The principle of exchanging equivalents, as one of achievement, has not abolished the family; but it has subordinated the family to itself. The inflation that repeats itself at brief intervals shows how manifestly anachronistic the idea of inheritance became, and the intellectual domain was equally crisis-prone. In the verbal expressions for tradition, the immediacy of the hand-to-hand is a mere residue in the social gears of universal mediation, where the commodity character of things is dominant. Technology has long since erased the memory of the hand that created it and is extended through it. In the face of technical means of production, the teaching of handicrafts is as substantial as

handicrafts themselves, which looked after tradition, not least the aesthetic kind. In a radically bourgeois country like America, people acted on this everywhere: tradition was considered either suspicious, or an imported article with alleged scarcity value. The absence of traditional elements over there, as well as the experiences that accompany of them, prevents a consciousness of temporal continuity; whatever does not present itself here and now as socially useful on the market has no weight, and is forgotten. If someone dies, it is as if they had never existed, being as absolutely replaceable as everything functional; only the functionless is irreplaceable. Hence the desperate, archaic rituals of embalming, which seek to avert by magic that loss of temporal consciousness which stems from the social conditions themselves. In all this, Europe is not ahead of America, which could learn tradition from it; it rather follows America, which does not even require imitation. The crisis of all historical consciousness, which is often noted in Germany and extends to an outright ignorance of even the recent past, is purely the symptom of a larger phenomenon. Evidently the context of time is falling apart for many people. The fact that time became so popular in philosophy shows that it is disappearing from the minds of the living; this is addressed in a book by the Italian philosopher Enrico Castelli. Contemporary art as a whole reacts to the loss of tradition: it has lost the traditionally validated self-evidence of its relation to the object and the material, and of its procedures, and must now reflect on them within itself. It feels the hollowed-out, fictitious nature of traditional elements, which significant artists smash away like plaster with a hammer. Whatever can be termed the intention of objectivity has the anti-traditional impulse. To lament this and recommend tradition as wholesome is helpless, and contradicts its own nature. Instrumental rationality, the consideration of how good it would be in an allegedly or genuinely deformed world to possess tradition, cannot prescribe something that is annulled by instrumental rationality.

art, working beneath their own level and drawing on education to borrow empty forms that cannot be filled; for no authentic art has ever filled its form. Rather, after the collapse of tradition, the artist experiences it in the way the traditional resists any attempt to take power of it. What is termed 'reduction' in the most varied artistic media today obeys the experience that one can no longer use anything but what is demanded by the gestalt here and now. The acceleration in the changes of aesthetic programme and direction, which the philistine mocks as the mischief of fashions, comes from the relentlessly increasing necessity of *refus* [refusal] first noted by Valéry. The relationship with tradition is translated into a canon of prohibitions. With growing self-critical awareness, this canon sucks up more and more, even what is seemingly eternal: norms that are directly or indirectly derived from antiquity and, in the bourgeois age, were mobilized against the dissolution of traditional elements.

# 4

However, while tradition is subjectively shattered or ideologically corrupted, it continues in historically objective terms to exercise power over everything that exists and everything into which it has crept. The belief that the world is an accumulation of mere givens without the deeper dimension of having-become, this positivist dogma that is at times difficult to distinguish from aesthetic sobriety, is as deluded as the invocation of tradition out of obedience to authority. Whatever believes itself to be ahistorical, a pure beginning, falls prey all the more easily to history, unconsciously and hence disastrously; this has meanwhile been demonstrated by the archaizing ontological tendencies in philosophy. The writer who resists the illusory aspect of tradition, and no longer sees themselves in any tradition, is nonetheless bound up in it from the outset through language

itself. What makes something literary is not an agglomeration of gaming chips; rather, the qualities of each word and each combination of words objectively gain their expression from their history, which is where the historical process as such is located. Forgetting, which Brecht once imagined as redemptive, has meanwhile turned into something mechanically empty; the poverty of the pure here and now has revealed itself as a merely abstract denial of false riches, and often as the apotheosis of bourgeois puritanism. Once stripped of any trace of memory, the moment is completely invalidated by the delusion that something socially mediated is a natural form or natural material. When its methods sacrifice what has been historically achieved, art regresses. Renunciation only has a truth content when it emerges through desperation, not in stubborn triumph. The happiness of tradition praised by reactionaries is more than just the ideology that it is. If someone suffers because of the omnipotence of the merely existent and yearns for what has never been, they may feel a greater elective affinity with a southern German market square than a reservoir dam, despite knowing how much the timber framework of the houses serves the conservation of stuffiness, the complement to mechanized ruin. Like doggedly self-confined tradition, absolute traditionlessness is naive; it lacks any inkling of all the past phenomena that inhere in the supposedly pure relationship with things themselves, untarnished by the dust of the disintegrated. But forgetting is inhumane, because it means forgetting the accumulated suffering; for the historical trace in things, words, colours and notes is always that of past suffering. That is why tradition confronts us today with an irresolvable contradiction: there is none that is present and can be summoned, yet if all trace of it is erased, the march towards inhumanity begins.

5

This antinomy dictates the possible attitude of the consciousness towards tradition. Kant's statement that only the critical path remains open is one of those eminently grounded principles whose truth content is incomparably greater than what is meant at any particular point. It applies not only to the particular tradition that Kant renounced, namely that of the rationalist school, but to tradition as a whole. Not forgetting it while not conforming to it means confronting it with the level of consciousness that has been attained, the most advanced level, and asking what is tenable and what is not. There is no eternal reservoir, no German primer whose merest idea is conceivable. There is, however, a relationship with the past that does not conserve, but does help some elements to survive through its incorruptibility. For all their restorative intentions, the important traditionalists of the previous generation, such as the George school, Hofmannsthal, Borchart and Schröder, felt something of this in so far as they gave the sober and compact precedence over the ideal. They were already sounding out the texts to see what rang hollow and what did not. They registered the transition from tradition to that which is unassuming and does not posit itself, and had more love for constructs whose truth content was deeply embedded in the material content than those in which it floats above the work as ideology, and is therefore not truth content at all. There is no better aspect of tradition on which to draw than this, the pull of the Enlightenment that was betrayed and disdained in Germany, an underground tradition of anti-traditionalism. But the sincere will to restoration also had a price to pay: its positivity became a pretext for an entire genre of elevated literature. The gritty, dignified character of Stifter imitators and Hebel exegetes is as cheap today as the bombastic gesture. Meanwhile, the purportedly unspoilt is absorbed into the overall manipulation of approved cultural artefacts; even major older works have been destroyed by recuperation. They reject the

restoration of what they once were. Objectively, even before they enter the reflecting consciousness, changing layers peel off from them by virtue of their own dynamics. Yet this creates the one tradition that should be followed; its criterion is correspondence. Being newly emergent, it casts light on what is now and receives its own light from it. Such correspondence is not one of empathy or immediate kinship, but instead requires distance. Bad traditionalism differs from the truth element in tradition because it denigrates distances, blasphemously clutching at the irretrievable, whereas it can only speak eloquently in an awareness of irretrievability. Beckett's admiration for *Effi Briest* exemplifies a genuine relationship based on distance. It teaches us how little the tradition that can be thought within the concept of correspondence tolerates the traditional as its ideal.

## 6

What is foreign to the critical attitude towards tradition is the gesture of 'We are no longer interested in that', as is the impertinent subsumption of present phenomena under overly broad historical concepts as mannerism, secretly following the maxim that there is nothing new under the sun. Such behaviour levels things out. It adheres to the superstitious belief in seamless historical continuity, and thus implicitly in the historical verdict; it is conformist. Where idiosyncrasy against past phenomena has become automatized, as it has towards Ibsen or Wedekind, it shows an aversion to those elements in such authors' work that were left unfinished, did not unfold or, like the emancipation of women, only did so fragilely. It is in such idiosyncrasies that one stumbles on the true theme of a reflection on tradition, on what has fallen by the wayside, been neglected and defeated, which can be gathered together in the category of obsolescence. It is there that the aliveness of tradition seeks

refuge, not in the survival of works meant to defy the passing of time. It eludes the sovereign view of historicism, in which superstitious belief in the everlasting and the zealous fear of the old-fashioned are fatally interlocked. The vitality of the works must be sought inside them, like layers that were hidden in earlier phases and only manifest themselves when others die off and fall away. It only becomes apparent that Wedekind's *Spring Awakening* assembled ephemera—the desks of schoolchildren and the sombre privies of nineteenth-century homes, the unspeakable quality of the twilit river outside the city, the tea that the mother serves to her children on a silvery tray, the chattering of the teenage girls about the engagement to Assistant Forester Pfälle—to form the picture of something imperishable, something that had always been there, after the play's wishes for timely enlightenment and tolerance for the youth have long been granted and have become insignificant, though these pictures would never have formed without them. The verdict of obsolescence is opposed by an understanding of the import of the matter, which renews it. One can only do justice to this with a behaviour that raises tradition to consciousness without bowing to it. Protecting tradition from the fury of disappearance is as necessary as wresting it from its own equally mythical authority.

## 7

A critical relationship with tradition as a medium for preserving it by no means only concerns the past, but equally the art whose quality makes it contemporary. In so far as it is authentic, it does not start breezily from scratch, outdoing one developed procedure with another. Rather, it is determinate negation. In all their perspectives, Beckett's stage works parodistically reshape the traditional dramatic form. The terrible games in which rubber weights are hefted with

deadly comical seriousness, and at the end everything is exactly how it always was, are responses to ideas such as a rising and falling plot, peripeteia, catastrophe and character development. Such categories have become the illusory superstructure over that which truly arouses pity and fear: the ever-same. In its viscerally present critique, the collapse of that superstructure provides the substance and import for a dramatic art that does not want to know what it is saying. To that extent, it is not a poor choice to speak of anti-drama, clichéd or not, or of the anti-hero. The central figures in Beckett are no more than doddering scarecrows of the subject that once dominated the scene. Their clownery passes judgement on the ideal of the self-aggrandizing personality, which deservedly perishes in Beckett's work. Certainly the word 'absurd', which has established itself for his dramatic works and those indebted to them, is inferior. It concedes too much to the conventional common sense that is on trial here; it pretends that the absurd is the mentality of such art, not the objective ill that it unmasks. Consenting consciousness attempts to swallow up even what is irreconcilable to it. Nonetheless, this embarrassing term is not entirely inaccurate. It designates advanced literature as a concretely executed critique of the traditional concept of sense, of the course of the world, which, until then, so-called 'high art' confirmed, not least where it chose tragedy as its governing principle. The affirmative nature of tradition collapses. Tradition itself asserts through its mere existence that sense is inherited in the fact of temporal succession. Any new literature—as well as music and painting—shakes the ideology behind the sense of that which, in the catastrophe, had cast off its semblance so thoroughly that doubt in it also sucks in past semblance. It abrogates tradition, yet follows it: it takes Hamlet's question on being or non-being so literally that it feels unable to choose the latter, which would be as misplaced in tradition as the prince's defeat by a monster in a fairy tale. Such productive critique is not contingent on philosophical reflection; it is

practised by the exact reaction of the artist's nerves and the technical control thereof. Both are saturated with historical experience. Each of Beckett's reductions presupposes the utmost abundance and nuance, even as he rejects them and lets them perish in the rubbish bins, sand heaps and urns, extending to the level of the linguistic form and the damaged jokes. Related to this is the insufficiency of the new novelists in the face of the fiction of the peep box into which they gaze, and about which they know everything. All this chafes at tradition, is angered by it for being the ornament, the deceptive production of a sense that is not. They remain loyal to that sense by refusing to feign it.

# 8

No less dialectical than the attitude of authentic works to critique is that of the authors. It is now less necessary than ever for a poet to be a philosopher, and it is also less permissible than ever if it means confusing the truth content of the matter with the pumped-in sense, which can only be referred to—and rightly so—with the ghastly word 'statement'. Beckett passionately fends off all reflection on the purported symbolic content of his work: its import is that there is no positive content. Nonetheless, something has changed in the attitude of the authors towards what they do; the fact they no longer find themselves in tradition, yet also cannot operate in a vacuum, shatters the concept of artistic naiveté so intimately intertwined with the concept of tradition. Historical consciousness is concentrated in the inescapable reflection on what is and is no longer possible, in the illuminated understanding of techniques and materials and the coherence of their relationship. It radically does away with the sloppiness that Mahler equated with tradition. Yet tradition survives even in the anti-traditional consciousness of what is historically due.

The artist's relationship with their work is now at once fully blind and fully transparent. Whoever behaves traditionally in the sense of imagining that they can say whatever comes into their head, fooled by the delusion of their individuality's immediacy, is all the more bound to write what is no longer possible. This does not mean the triumph of the sentimentally thinking artistic type who had contrasted with the aesthetic self-identity of naiveté since the Classical-Romantic period. They become the object of a second reflection that takes away their right to posit sense, the right to the 'idea' that was bestowed by idealism. In this sense, the advanced aesthetic consciousness converges with the naive kind, whose conceptless intuition made no claim to any sense, and perhaps gained it at times precisely because of that. But one cannot rely on this hope any longer either. Literature can only salvage its truth content by repulsing tradition while being in the closest contact with it. Whoever does not want to betray the bliss that tradition always promises in some of its pictures, the possibility that lies buried beneath its ruins, must turn away from any tradition that misuses possibility and sense for lies. Tradition can only return in that which implacably rejects it.

# Scribbled at the Jeu de Paume

If one turns one's attention not to the perceptual form and manner of painting of the French impressionists but to the objects of their pictures, one is drawn to conclude that their landscapes are filled with all possible signs of modernity, especially aspects of technology. This is what expressly distinguishes them from their German successors. While the latter wish to devote themselves to the play of the sun's reflections inside a forest without disturbing nature, disturbance is practically the vital principle of the great French painters. The rivers with railway bridges that they prefer have, perhaps in recollection of Roman aqueducts, a tendency almost to echo the counterpoint of their surroundings, or at least to appear old, as if they themselves were the nature from which the stones in them often originate. But the pictures want to enact this merging of opposites in themselves: absorbing the shocks inflicted on the nerves by artefacts that have turned against the body and eyes of humans. The universally known character of the impressionist method—the dissolution of the material world into its perceptual correlates and the attempt to bring them home into the subject—is only revealed in the choice of object. Something that defies experience will gain experience after all, and the estranged will become closeness. That is really the impulse with which the concept of modern painting has been formed. Pictorial realization even seeks to make the estranged equal to the living, to rescue it for the realm of life. This innovation was eminently conservative in its intention. The power with which

this intention was unconsciously implemented in the style of painting gives impressionism its depth. This aspect at once sublimates itself from something material into something purely painterly: Sisley's fascination with the snow presumably means that the part of nature which has died off, the wintery blanket, has its visual life wrested away from it like the iron objects it no longer requires, which even Sisley's eye wished to spurn as all too coarse an irruption of the world of things into his colouristic continuum. The fact that the grey things have colourful shadows in all the painters' works is not simply what one assumes it to be, namely a peculiarity of the technique, but rather the sensual appearance of such a metamorphosis. And Pissarro's bald trees, the opposing vertical lines transecting the colour fields, already transform the concrete disturbances that the impressionists were concerned with mastering into formal elements. It is permitted to speculate that the transition of impressionism into construction, and thus the constructive aspect of modern painting in contrast to the expressive, emerged in that concrete layer.

Apples in a still life by Manet, hard, contoured, removed from any flowing play of colours, recall still lives by Cézanne. Such is the intricacy of progress in art: the older can overtake the newer. It is this very act of overtaking that constitutes the element of survival in works of art: overall, Manet seems more modern, more defamiliarized than the more high-resolution, more resolutely technically innovative works of high impressionism. One can find the same thing later on in Van Gogh. Some of his pictures resemble those of Hodler today, more art nouveau than impressionism; incidentally, Monet too—and by no means only the later Monet—displays an art nouveau side, especially in his large-format works, such as 'The Turkeys'. With Van Gogh, some elements have come to seem more like effects than *peinture*, stage decoration for unrealistic plays rather than unrealistic themselves, as with the lurid theatre colours of

'L'église d'Auvers-sur-Oise'. I once had a similar impression in music terms, at a concert in Darmstadt in which Ravel's *Chansons madécasees* outshone the far more materially advanced String Quartet No. 4 by Bartók by virtue of their sheer compositional quality. In a peculiar fashion, quality wins out over the material employed, yet this still requires the evolution of the material; had there been no Bartók after Ravel, that quality which outlasts Bartók would not have emerged. One might be inclined to doubt such an outlasting in Van Gogh's case, especially in the age of his fame. But does art really revolve around the question of what remains? Is the very question not itself a symptom of reified consciousness, an emulation of property, and hence unsuited to the idea of the momentary that fuels every work of art and almost became thematic in impressionism? Is the true immortality of art not an instant, that of explosion? Then Van Gogh would certainly be without equal. I once shared these rambling reflections with a friend, an expert on Picasso like no other. I argued that one should not defend him from the suspicion of fashion, but rather defend the fashion within him as the metaphysical striving of the work to throw itself away to the moment *à fonds perdu*.[1] Just as there is no great work of art from recent years in Paris that is not somehow marked by fashion through a certain elegance, however hidden, so too, I suggested, Picasso should try his hand at making things that consist only of fleetingly draped cloth. But my friend rejected this notion, stating that Picasso, a Proteus of himself and all materials, did want his creations to survive. Ultimately, is he too a conservative?

Everyone knows that impressionism splits objects into spots of colour, light and atmosphere, and thus subjectifies the image of the world. But the less the objects as they are, in all their randomness,

---

1 'With no prospect of recompense'. [Trans.]

reign any longer over the picture, the more they are freed up for construction: what is painted can only be fully organized in the moment when it is no longer governed by anything external. Only when the matter has gone fully through the subject can it gain subjectivity once again. Reconciliation with the object only succeeds, if at all, through its negation. This is what is overlooked in all defences of realism; their view of the work's objectivity is too short-winded. No predefined objectivity can be maintained; none can be hoped for except one in which the subject, thrown back entirely upon itself and, in utmost discipline, renouncing whatever it cannot fill, turns into something else precisely through that renunciation.

Manet's new finds—the discovery of unmitigated contrasts, the emancipation of colour from all preconceived harmony—are all connected to evil. The shocks of the colour combinations, which can still be felt with the full force of the first time today, express the shock that must have been visible around the middle of the nineteenth century in the faces of the cocottes who were Manet's models: that beauty can exist in the paradoxical unity of the undestroyed and that which destroys. In Manet, for whom social movement is still undivided from artistic movement, we see the following painted onto one another: social critique, namely the shudder at what the world does to humans; and the delight at the stimulation provided to the dulled collective consciousness by the very thing that itself falls victim to negative collectivity. Today, then, the paintings of Manet rhyme with Baudelaire.

I tried to understand for myself why I cannot develop any real connection to the indescribably virtuosic and original paintings of Toulouse-Lautrec. It is probably down to the specific talent itself: the élan that reminds me fatally of what is referred to in music with the abhorrent word 'minstrel-like' [*musikantisch*]. It is the prompt

painter's eye whose affinity with things proclaims affinity with the world, waiting for the answer to an 'aha' as if one should long have recognized it. One imagines a father who, with the inexperienced yet self-assured manner of the expert, points at such a poster and says, 'The man has talent'. In Lautrec, the shocks registered by Manet have become effects to exploit; the unfailing eye and the hand that does not hesitate can be disposed over, and while everyone insists that commercial art can be great art too, its triumph over advertising benefits advertising. In much the same way, the tip is already written into the primordial nature of fiddling minstrels. On this journey to the end of the night, one sees an unrolling tourism being fed in the side streets of Place Pigalle by the whistles of pimps, as if rehearsed by some district authority. It is no coincidence that a colour film has been made about his life: blood and soil in asphalt.

To know seriously whether a work of art is good or bad, one must understand the specific technique. Those late, rosy Renoirs, the fruit bodies, round to the point of asensuality, truly *jeunes filles en fleurs*,[2] but no Albertine—I bristle at them, as if they were made for export, and simply cannot reconcile them with the ingenious landscapes, groups and portraits from his earlier period. Are they the autonomous painterly consequence of that vegetative feeling which Samuel Beckett considers Proust's centre, and which perhaps defines the unity of art nouveau and impressionism, or are they actually a testimony to the loss of tension in a painting at the very moment when it establishes itself?—a loss of tension, incidentally, that Monet, who outlived Renoir, was evidently spared. I do not know; in music I would know.

---

2 A reference to Proust's *In the Shadow of Young Girls in Flower*, the second volume of *In Search of Lost Time*; Albertine Simonet is the central love interest of the narrator and appears at various points throughout the cycle. [Trans.]

Farewell: the Eiffel Tower, viewed at close range from below, is a grisly monster—'squat', as someone said in English, broad on four short, massive, crooked legs, greedily waiting to see if it can yet devour a city that remained intact as so many ruinous images rolled by. From a distance, however, the Eiffel Tower is the slim, hazy symbol that extends indestructible Babylon into the sky of modernity.

## From Sils Maria

In the distance a cow busying itself by the lake, grazing between boats. An optical illusion made it seem as if she were standing in a boat. What cheerful mythology: the Bull of Europa navigating triumphantly across the River Acheron.

With visible contentment, the cows in the mountains march along the broad paths made by humans, but without paying much attention to them. A model for how civilization, having suppressed nature, might care for what it has suppressed.

From high up, the villages look as if they had been placed there from above with light fingers, moveable and without foundation. They thus resemble toys, with the promise of happiness offered by the fantasy of gianthood: the idea that one can do whatever one likes with them. But our hotel, in its excessive dimensions, is one of the tiny tin-crowned buildings that decorated the tunnels raced through by toy trains in the childhood home. Now one finally enters them and knows what is inside.

In the evenings we had to watch Sputnik from the roof. It would have been indistinguishable from a star or Venus but for the wobbliness of its orbit. That is the nature of humanity's triumphs: the thing with which they dominate the cosmos, the dream made reality, is divinely wobbly, as helpless as if it were about to fall.

No one who has heard the sound of marmots will easily forget them. To call it a form of whistling is inadequate; it sounds mechanical, as if driven by steam—which is precisely what makes it shocking. The fear that these small animals must have felt since time immemorial has been frozen into a warning signal in their throats; that which is meant to protect their life has lost all expression of the living. Seized by panic in the face of death, they mimic death. If I am not mistaken, the growth of camping over the last 12 years has driven them ever further into the mountains. Even the whistling with which they uncomplainingly indict the nature-lovers has become rare.

Their expressionlessness is matched by that of the landscape. It exudes no middling humanity; this lends it the pathos of distance found in Nietzsche, who hid there. At the same time, the moraines that characterize this landscape resemble industrial waste dumps, rubble heaps left by mining. Both things, the scars of civilization and the untouched lands beyond the tree line, run counter to the idea of nature as something designed to comfort and warm humans; it already reveals how things are in the cosmos. The popular imago of nature is limited, bourgeois in its narrowness, calibrated to the tiny zone in which historically familiar life flourishes; the country lane is the philosophy of culture. Where the domination of nature destroys that ensouled and deceptive imago, it seems to approach the transcendent sorrow of space. The greater illusionless truth of the Engadin landscape in comparison to the bourgeois countryside is offset by its imperialism, its acceptance of death.

Peaks that break through the fog and tower over it seem incomparably higher than when they rise in the light of day, unconcealed. But when Piz da la Margna wears her light shawl of mist, playful yet reserved, she is a lady who one can be sure would never travel to St Moritz to go shopping.

In the Pensiun Privata, which is still frequented by intellectuals today, there is an old guestbook with an entry by Nietzsche. It lists his occupation as university professor. His name is directly below that of the theologian Harnack.

The house in which Nietzsche lived is defaced by an unspeakably philistine inscription, but it shows with how much dignity one could be poor 80 years ago. Today, under similar material conditions, one would be demoted as member of bourgeois society; considering the ostentatiously high overall standard, one would feel humiliated by such frugality. Back then, one bought intellectual independence by living with the utmost modesty. The relationship between productivity and one's economic foundation is also subject to history.

Cocteau wrote knowledgeably that Nietzsche's judgements about French literature were based on the stock of the station bookshop in Sils Maria. But there is no railway in Sils, no station, no station bookshop.

The stories about the stack of Nietzsche's dusty manuscripts stored in the basement of Hotel Edelweiss are definitely apocryphal. If anything of the kind existed, researchers would have unearthed it long ago. It seems one must abandon the hope that any unknown material would enable a settlement of the dispute between Lama and Schlechta.[1] But I learnt some years ago that the manager of the opu-

---

1 'Lama' was the nickname of Nietzsche's sister Elisabeth Förster-Nietzsche (1846–1935), who founded the archive dedicated to her brother's work and edited publications thereof. Nietzsche expressed deep antipathy towards her and her worldview, and she was largely responsible for the appropriation of his philosophy by National Socialist ideology. In 1959, the Austro-German author and teacher Karl Schlechta (1904–1985), who had worked at the

lent local grocery shop, Mr Zuan, met Nietzsche during childhood. We went there, Herbert Marcuse and I, and were received cordially in a sort of private office. And Mr Zuan did indeed remember: on closer questioning, he related that Nietzsche had carried a red umbrella come rain or shine, presumably hoping thus to ward off his headaches. A band of children, including Mr Zuan, were having fun placing little stones in the folded umbrella so that they fell on his head as soon as he opened it. Then he ran after them, holding the umbrella aloft and uttering threats, but never managed to catch them. We imagined how difficult the situation must have been for the suffering man, who pursued the pests in vain and possibly even agreed with them in the end, since they represented life against the spirit—unless the experience of actual pitilessness caused him to be bewildered by certain philosophemes. Mr Zuan could not recall any further details, but could certainly have told us about Queen Victoria's visit, and was quietly disappointed that it was less important to us. Mr Zuan has died in the meantime, over 90 years old.

Nietzsche Archive in the 1930s, published a new edition of Nietzsche's works and pointed out the many distortions and misrepresentations in Elisabeth Förster-Nietzsche's edition. [Trans.]

# Non-Conciliatory Proposal

The division of people into friends and opponents of new art rests on a fallacy. It supposes a certain arbitrariness of behaviour based on the inartistic bourgeois convention of taste as a mere preference or aversion. One cannot, in a crude analogy with the rules of political parliamentarianism, decide for or against new art as in the two-party system, where one is presented with two 'tickets' whose connection to one's own interests and views is meant to be at least somewhat transparent. The air of liberality is used to conceal the very thing that is most crucial in aesthetic controversies: the relationship with the object itself. One can scarcely doubt that, generally speaking, those who identify with the tendency of new art—which need not mean that they consider every new picture good, any more than an art historian automatically loves every third-rate altarpiece in a god-forsaken Baroque church—are those who understand it, who are receptive to its impulses and its realization and submit to the discipline imposed by each individual qualitatively new work upon the viewer or listener. But the principal opponents are the clueless, those for whom a tachist painting quite literally looks like a mass of spots and a score by Boulez sounds as exotic as the percussion instruments it features. They feel entitled to pounce on what they do not understand, taking it for granted that all sensible people share their incomprehension. Behind their apparent admission that they themselves are at fault lies a condemnation not based on any judgement. Their modesty is a lie, the same fatal self-stylizing as that of the plain,

honest German who feigns naiveté and guilelessness in order to claim that he is constantly being cheated, a perennial victim of the manipulations that, according to time-honoured custom, are also conjured up by those who accuse new art of being managed. Those who are proud not to understand should not be chosen as partners when judgement presupposes the very understanding they deny in themselves. They would do better to be silent than to put their incomprehension in the balance.

If I am speaking all too summarily, it is certainly less so than those for whom thinking in stereotypes is a central behaviour and who ramp up their own outrage, as if each of them were their own Goebbels. At times, the idiosyncratic rejection of the new actually contains a closer unconscious experience of what it encounters than the puny faith in the unity front of all immortals found today, which would be only too happy to call Picasso a new Raphael. Over the last hundred years, Victor Hugo's statement in his book on Shakespeare that one can only reach the same level as the old masters by doing something different has revealed its full truth. However, if the idiosyncrasies of the foes are a reaction to something the friends explain away all too easily, to the detriment of the works, then the former should not content themselves with their idiosyncrasy, with the mere unease from which experience begins; rather, they should transform it into the power that leads inside the matter itself, and thus legitimizes the judgement in the first place.

I am aware that there are those foes who certainly do understand. But I cannot help myself: if I read a subtle, precise, highly accurate analysis of Cézanne in one of their central texts, I sense in such understanding a sympathy that is suppressed by the thesis only with some effort. I am not convinced by the indignation of anyone with such an eye for Cézanne, and they will scarcely believe it themselves. This shows itself in those historico-philosophical passages where, for all the reasoned justifications of stubborn prejudices, the

fact shines through that no art is possible here and now except for that which is being damned to hell. One can witness something similar with the aestheticians of the Eastern Bloc, incidentally, whose administrative hatred for new art harmonizes all too well with the Western cultural conservatism of the free world. When Lukács rails against Kafka, it is simultaneously clear that he prefers him to the pulp literature of Socialist Realism, just as one suspects that the backward-looking cultural critic who provides the philistines with their slogans secretly likes Cézanne.

In the light of this, I would argue for replacing the division into friends and opponents with that into friends and the German Hotel Painting Association (GHPA). Let no one say that there is no such thing; after all, the pictures that return in hotel rooms as steadfastly as eternal values return among philosophy professors must come from somewhere. One fine day, in a large Munich hotel, I discovered a shop where all of this was concentrated: the heaths, the lakes that reflect the moon, the goose-pluckers and the floral still lives; I do not know whether the owner was perhaps even a manager. If one equates the resolute opponents of new art with those who relish hotel painting, one will probably not catch all of them—but one will, to use their own jargon, clear the air. This would also help them to achieve the organization that they jealously attribute to others. Then they would all be assembled: the Spitzwegians with their sunny, conciliatory humour; the post-Maréesian[1] gin-sippers with their foreground lines; the earnest symbolists à la Thoma and the earthy Percheron[2] lovers à la Boehle; a wealth of mediocre painting with a guarantee of genuine, existentially connected statements on country lanes and up garden paths, an unfettered orgy of the country's quietest. One can add a few bearded art nouveau geriatrics and some commercial impressionists;

---

1 Hans von Marées (1837–1887) was a German painter. [Trans.]
2 A breed of draught horse. [Trans.]

I know one who is painting Miss Nitribitt's[3] turf as if it were the boulevards of Paris and he were Monet, and the admirers are in a feeding frenzy over it. And let us not forget the sailing boats in the harbour of Portofino! The place of honour, however, may belong to a painting of Ganghofer's funeral service, showing him being rowed across the Königssee by six hunters while roaring St Hubert stags[4] stand on the shore and shed crocodile tears. Hotel painting and modern painting: there is really nothing else left. *Tertium non datur*. At times some older pictures look like hotel paintings, even when they are not.

I would be very accommodating towards hotel painting and suggest that the other kind, in whose organizational power it has such faith, could provide it with an exhibition of its own—a countersecession, as it were, with non-degenerate art. Then everyone who was waiting anyway could crawl out from under their rocks, having happily survived the Third Reich. Such an exhibition, diagonally opposite from one with Winter and Nay, Emil Schumacher and Bernard Schultze, would not resolve the question of management, but would make it obsolete. For truly, hotel painting has no need of managers, since it lives off healthy public feeling; so let it admit as much, without blushes. The house of the hotel painters will not lack an influx of visitors, perhaps even a greater one than for the 'Degenerate Art' exhibition. But one will surely be allowed to take a closer look at the crowds. In 1950 a book was published in America with the title *The Authoritarian Personality*; although I was far from uninvolved, a highly objective survey confirmed it as the most influential sociological work of its time. It examined, somewhat drastically and crudely but with a wealth of material, two types, the

---

3 Rosemarie Nitribitt (1933–1957) was a German courtesan who worked mainly in Frankfurt and was murdered there, resulting in a major scandal. [Trans.]

4 Saint Hubert (c. 656–727) is often depicted in the company of a stag with a crucifix between ist antlers, a reference to a story from a hagiography. [Trans.]

'highs' and the 'lows': on the one hand, those who are authority-bound, prejudiced, rigid, conventional and conformist in their reactions, and on the other hand, the autonomous ones, who are free of blind dependencies and open to dialogue. The authority-bound sympathized more or less openly with the fascism that was flourishing at the time. If people in Germany were not too inward-looking to engage with such tests, there would probably be a fairly high correlation between the members of the GHPA and the authority-bound character structure. After the unspeakable horror of what happened, their concern for the pure, irrational immediacy of the soul's life is politically abhorrent, even if they are unaware of it.

Oh, how absurd to ask whether modern art is politically managed; as if hotel painting were not supported by the united majority, the establishment and its entire apparatus; as if what they proclaim were not nefariously ingrained second nature, which can mobilize the full gravity of what happens to exist for its purposes. As if hotel painters did not know that in liberal society, painters and even hotel painters need the art dealers if they do not want to starve. In the administered world, they need major institutions for the same purpose, ones that are supportive enough to grant them shelter and thus practise something resembling self-correction. What would have become of the impressionists without Vollard, what of Van Gogh without Théo? Let no one say that the hotel painters would be happy if those artists, their silent conscience, had been ruined. But they have no conscience, only their ethos. Without the help of Renoir and Van Gogh, even today's hotel painters could not cover the walls of hotel rooms with their mess. Even the negative eternity of kitsch has its history; it regenerates through the decayed cultural artefacts of the upper class.

Compared to such power and glory, the management that allowed the œuvres of Picasso and Klee to develop is as modest as it is inescapable; as long as art has anything to do with breadwinning,

it requires the economic forms that are appropriate to the period's conditions of production, and those who complain most loudly about management and profit interests are the first to conform to the demands of the market. But one should not take the full-throated invocations of personality and the soul with which they rail against Americanism, whose blessings they would certainly not spurn, any more seriously than the maudlin assertions that modern art is being forced on the innocent populace by jobbers. The mask of cultural innocence is based on a highly political model. Did Hitler not cry out into the world that only he and his faithful helpers had saved Germany, while the others had control of the radio, the press, indeed all the power in the world? He knew a great deal about management; he even managed death, and the spontaneity he claimed for himself was never much more than a front. He had his backers from day one; he himself was managed from the start, an exponent of the real power that lay beyond the feeble power of the state. He only intoned his lament over the alleged system to exploit the dull rage of those who constantly felt cheated by the powers and their advertising for the purposes of the very same powers. The argument that someone was trying to force an art on the people that was foreign to them was already familiar to the reactionary battle leagues of the Weimar period. It did not get any better after its direction became clear. Invoking democracy where the ballot paper does not belong only serves the purpose of insidiously defaming democracy. They lust after an order in which, as in the eastern zone, terror prevents the unregulated, uncontrolled, unmanipulated—in short, unmanaged— voice of humanity from making itself heard. The declamations about managed modern art correspond exactly to what psychology knows as projection: ascribing one's own actual or desired characteristics to those one hates. Whoever appeals to the liberty of the spirit to oppose liberated art is, in reality, seeking to ruin what is left of it. It is no coincidence that someone of this ilk accused West German

Radio of wasting public funds because it maintains the electronic studio. He would have liked to cut off the material and technical preconditions for avant-garde music, but was given the appropriate response at the convention of a protestant academy. I am no expert on painting, but I would be very mistaken in my instinct if the ethos of the hotel painters were not cast in the same mould.

Must I ward off the misconception that new art is secure and has an easy time of it? It would be a troubling compliment if it were true; the world is out of joint, and artists can safely leave it to the totalitarian managers on both sides to insist that it makes sense. I claim the right to talk turkey with the hotel painters because I have not concealed the antinomies of new art in any way. Hans Sedlmayr[5] knows that very well, which is why he has referred to me on several occasions, admittedly not in agreement with me. One should not believe that the new art is the way it is because the world is so bad, and that it would be better in a better world; this is the hotel painting perspective. To be sure, it can be shown that everything objectionable in the new art is driven by a critique of traditional art, that every distorted form unmasks the all-too-smooth ones hanging on the walls of our museums, and every negation of the objects strikes at their panegyric doubling—in short, that the new art discards the affirmative nature of traditional art as a lie, as ideology. It is not the new art that should be ashamed of this, but rather the old untruth. The hotel painters are quite right: it is not harmless. No one who has experienced it can tolerate harmlessness any longer. The less it allows the force of resistance to dwindle within it, the more effectively it will resist the accusation of being managed.

---

5 Hans Sedlmayer (1896–1984) was an Austrian art historian and advocate of figurative painting; he was a member of the Austrian Nazi Party from 1931 to 1932 and 1938 to 1945. [Trans.]

# The Culture Industry: A Résumé

I believe the term 'culture industry' was first used in the book *Dialectic of Enlightenment,* which Horkheimer and I published in Amsterdam in 1947. In our sketches we referred to 'mass culture'. We replaced this with 'culture industry' in order to disable from the outset the interpretation that is agreeable to those who espouse it, namely, that it resembles a culture arising spontaneously from the masses themselves, the contemporary form of folk art. The culture industry could not be more different: it combines familiar things to produce a new quality. In each of its branches, products are manufactured more or less methodically; they are tailored to consumption by the masses, and to a considerable extent determine this consumption themselves. The individual branches are similar in structure, or at least fit together. They join almost seamlessly to form a system. This is enabled both by the technology of today and the concentration of business and administration. The culture industry is the deliberate integration of its customers from above. It also forces together the realms of high and low art, which were separated for centuries—to both their detriment. High art is stripped of its seriousness by aiming for effect, while low art, having been tamed and civilized, loses the wildly resistant quality that inhabited it before society gained total control. While the culture industry undeniably bets on the state of (un)consciousness of the millions it addresses, the masses are not primary but secondary, something that has been factored in: appendages to the machinery. Contrary to what

the culture industry would have us believe, the customer is not king; not its subject, but rather its object. The term 'mass media', which has established itself for the culture industry, already shifts the emphasis towards harmlessness. The foremost concern is not the masses, nor the techniques of communication as such, but rather the spirit that is breathed into them, the voice of their lord. The culture industry abuses the consideration for the masses in order to duplicate, consolidate and reinforce the mentality that is presupposed as given and immutable among them. Anything that might change this mentality is consistently excluded. The masses are not the measure of the culture industry but its ideology, even though it could not exist without adapting itself to them.

The cultural commodities of the industry follow, as Brecht and Suhrkamp already stated 30 years ago, the principle of commercial exploitation, not their own import and self-consistent design. The entire practice of the culture industry applies the profit motive starkly to products of the spirit. There has been an element of this in them ever since they began providing their creators with life as commodities on the market. But they strove for profit only indirectly, through their autonomous essence. What is new about the culture industry is the direct, undisguised primacy of effect, which is precisely calculated in its most typical products. The culture industry tends towards an elimination of the autonomy of works of art, which was admittedly barely ever pure and always pervaded by contexts of effect, with or without the conscious will of those in control. These are both executive bodies and power brokers. In material terms, they are or were in search of new ways to exploit capital in the most economically developed countries. The old ways grow ever more precarious because of the same process of concentration without which the culture industry as an omnipresent institution could not exist. When culture, whose own sense never lay merely in serving people, but which honoured them by also objecting to the conditions in which

they lived, adapts completely to them, it is integrated into the hardened circumstances and debases people once more. Spiritual products in the style of the culture industry are no longer *also* commodities; they are commodities through and through. This quantitative shift is so great that it brings about entirely new phenomena. After all, the culture industry no longer needs to pursue the profit interests that formed its point of departure directly; they have materialized in its ideology, at times even becoming independent of the need to sell the cultural products, which have to be swallowed anyway. The culture industry turns into public relations, the creation of *good will* as such, independently of particular firms or marketable objects. It sells general uncritical agreement, it advertises the world, just as every product of the culture industry is its own advertisement.

Yet this captures the features that once characterized the transformation of literature into commodity. If anything in the world has its own ontology, a framework of rigidly conserved basic categories, it is the culture industry; they can be seen in the commercial novel in England during the late seventeenth and early eighteenth century, for example. What presents itself as progress in the culture industry, the constant novelty it offers, remains the outer shell of the eversame; every instance of variety conceals a skeleton that changes as little as the profit motive itself has changed since gaining dominance over culture.

One should not take the word 'industry' literally in this case. It refers to the standardization of the matter itself—as in the western genre, familiar to every cinemagoer—and the rationalization of the methods of dissemination, though not strictly the production process. While, in the heart of the culture industry, the film sector, this process increasingly resembles technical procedures through the advanced division of labour, the use of machines and the separation of the workers from the means of productions—this conflict is expressed in the eternal conflict between the artists working in

the culture industry and the powers that be—individual forms of production are retained nonetheless. Every product poses as individual; individuality itself is suitable for reinforcing ideology by creating the impression that the fully reified and mediated is a refuge for immediacy and life. The culture industry still consists in the 'services' of third persons and retains its affinity with the dated circulation process of capital, trading, from which it originated. Its ideology relies above all on the star system borrowed from individualist art and its commercial exploitation. The more dehumanized its activity and its content, the more busily and successfully it propagates supposedly great personalities and pulls on heartstrings. It is industrial, more in the sense of the adaptation to industrial forms of organization often observed in sociology, even where nothing is fabricated—recall the rationalization of office work—than in the sense of actual technological-rational production. Accordingly, the misinvestments of the culture industry are considerable, and send those branches made obsolete by newer technologies into crises that rarely lead to improvements.

Going purely by the word, the concept of the technical in the culture industry is the same as in works of art, where it refers to the organization of the matter in itself, its inner logic. By contrast, the technical in the culture industry, which is first of all the aspect of dissemination and mechanical reproduction, thus always remains external to its matter. The culture industry is ideologically buttressed by the fact that it carefully protects itself from the full consequences of its technical methods in the products. It lives almost parasitically off the extra-artistic technique of producing material goods, without honouring the responsibility that its objectivity constitutes for the intra-artistic design, but also without regard for the formal law of aesthetic autonomy. This results in the culture industry's central mixture of streamlining, photographic hardness and precision on the one hand, and individualistic residues, moods and a prepared,

already rationally planned Romanticism on the other. If one takes up Benjamin's definition of the traditional art work based on the aura, the presence of something non-present, then the culture industry is defined by the fact that it does not contrast the auratic principle strictly with another, but rather conserves the decomposing aura as an atmospheric smokescreen. In doing so, it directly indicts itself for its own ideological mischief.

It has now become common for cultural politicians and also sociologists, pointing to the great importance of the culture industry for educating the consciousness of its consumers, to warn of underestimating them. In fact, the culture industry is important as an aspect of the prevailing spirit of today. Anyone who ignores its influence out of scepticism towards what it stuffs into people is naive. But the warning to take it seriously appears dubious. For the sake of its social role, irksome questions as to its quality, its truth or untruth and the aesthetic standard of what it conveys are suppressed, or at least removed from the so-called psychology of communication. The critic is accused of hiding behind arrogant esotericism. One should begin by pointing out the twofold sense of meaningfulness that creeps in unnoticed; the function of a matter is no guarantee of its quality, even if it affects the lives of countless people. The mingling of the aesthetic and its communicative scum does not lead art, as something social, to assume the correct relation to the supposed haughtiness of the artiste; instead, it often serves to defend something that is *funest*[1] in its social effects. The importance of the culture industry for the emotional makeup of the masses offers no exemption, least of all for a purportedly pragmatic science, from reflecting on its intrinsic nature beyond its objective legitimation; rather, it necessitates precisely this. Taking it as seriously as befits its undeniable role means taking it seriously in a critical fashion, not hiding from its monopoly.

---

1 French for 'fatal' or 'disastrous'. [Trans.]

Among those intellectuals who are willing to accept the phenomenon, and who attempt to strike a balance between their reservations about the matter and their respect for its power—assuming they do not make a new twentieth-century myth out of the heightened regression—one often encounters a tone of ironic indulgence. One knows what it all means, after all, the magazine novels and generic films, the family dramas stretched out into television series, the hit parades, the agony aunts and horoscope columns. But it is all harmless, they say, and democratic too, since it follows public demand (however artificially stimulated), and has numerous benefits, such as the spread of information, advice and relieving behavioural patterns. However, the information, as every sociological study on something as basic as the state of political knowledge shows, is impoverished or inconsequential; the advice one elicits from the manifestations of the culture industry is insipidly banal or worse; and the behavioural patterns are shamelessly conformist.

The mendacious irony in the relationship between meek intellectuals and the culture industry is by no means restricted to the former. It is reasonable to assume that the consciousness of the consumers themselves is split between the prescribed fun administered to them by the culture industry and their doubts as to its blessings, which are no longer even particularly concealed. The statement that the world wants to be fooled has become truer than its originators would ever have thought. Not only do people fall for a scam if it promises them gratifications, however fleeting; they even desire the deception despite seeing through it, frantically closing their eyes and, in a kind of self-contempt, affirming what is happening to them while knowing why it is fabricated. Without acknowledging it, they sense that their lives would become entirely unbearable if they stopped clinging to forms of gratification which are anything but.

The most advanced defence of the culture industry today celebrates its spirit, which one can safely term ideology, as a factor of

order. It gives people in a supposedly chaotic world something like points of orientation, and this already merits approval. What they believe to be preserved by the culture industry, however, is all the more thoroughly destroyed by it. Technicolor demolishes the cosy old inn more than bombs ever could: it exterminates its imago too. No home[2] survives the way it is presented in the films that celebrate it, turning anything unmistakable on which they feed into an interchangeable feature.

Whatever could formerly be termed culture *sans phrase* sought, as an expression of suffering and contradiction, to capture the idea of a right life—not to present mere existence, along with the conventional and now non-binding categories of order with which the culture industry adorns it, as if it were the right life and those categories its measure. If the advocates of the culture industry counter that it does not produce art, then even this is ideology, and seeks to evade responsibility for the very thing on which the business thrives. No iniquity is made better by declaring itself as such.

To invoke order as such without any concrete definition thereof, along with the dissemination of norms that are not required to identify themselves, has no validity. An objectively binding order of the kind one talks people into accepting for want of any other is null and void unless it proves its validity both internally and in relation to people, and that is precisely what no product of the culture industry would accept. The concepts of order they hammer home are always those of the status quo. They are imputed without question, analysis or dialectic, even if they no longer have any substance for those who put up with them. The categorical imperative of the culture industry, unlike that of Kant, no longer has anything to do with freedom. It is

---

2 The use of the word *Heimat* ('home, homeland') automatically invokes the *Heimatfilm* genre, which idealizes a sense of national 'home' through idyllic settings. [Trans.]

this: you must submit, without knowing to what; submit to what is the case anyway, and which, as a reflex to its power and omnipresence, everyone believes anyway. Through the ideology of the culture industry, consciousness is replaced by adaptation: the order that springs from it is never confronted with what it claims to be, or with people's real interests. Order is not inherently good, but only if it is the right one. The fact that the culture industry pays no attention to this, instead praising order *in abstracto*, only proves the impotence and untruth of the messages it conveys. While it claims to be the leader of the perplexed, inducing them to confuse their own conflicts with illusory ones, it only seemingly solves these conflicts, just as they cannot solve them in their own lives. In the products of the culture industry, people only experience difficulties so that they can, usually thanks to representatives of a perfectly benevolent collective, overcome them and then, wearing rose-tinted glasses, affirm the universals whose demands they initially experienced as irreconcilable with their own interests. To this end, the culture industry has developed schemata extending even into such non-conceptual areas as light music, where one can also get into a 'jam', into rhythmic problems, that are immediately solved with the triumph of the strong beat.

Yet even the defenders will scarcely contradict Plato openly in his assertion that whatever is objectively false in itself cannot be subjectively good and true for people. The concoctions of the culture industry are neither guidelines for a blissful life nor a new art of moral responsibility, but rather warnings to counter something that is propped up by powerful interests. The consent it propagates reinforces blind, unilluminated authority. If, in keeping with the culture industry's position in reality and its own purported demands, one measured it not by its own substantiality and logic but by its effect, and if one concerned oneself seriously with the thing it constantly invokes, then the potential of such effect would weigh twice as

heavily. But such is the promotion and exploitation of the ego weakness to which today's society, with its concentration of power, condemns its powerless members. Their consciousness regresses further. It is no coincidence that one can hear cynical film producers in America saying that their movies should take into account the level of 11-year-olds; in doing this, what they would like most of all is to turn adults into 11-year- olds.

To be sure, the regressive effect has not yet been proved beyond doubt through exact research for individual products of the culture industry; imaginative experiments could certainly do this better than the financially powerful clients would like. One can safely assume, at any rate, that constant dripping wears the stone, all the more so because the system of the culture industry surrounds the masses, scarcely tolerates evasions and constantly rehearses the same behavioural schemata. Only their deeply unconscious distrust, the last vestige of the difference between art and empirical reality in their spirit, explains the fact that not all of them have long since begun to see and accept the world as it is dressed up for them by the culture industry. Even if its messages were as harmless as they are made out to be—and on countless occasions they are not, any more than the films that join in with the currently popular anti-intellectual incitement purely through their use of typical characteristics—the attitude brought about by the culture industry is anything but harmless. If an astrologist warns their readers to drive carefully on a particular day, it will certainly do no harm; what will, however, is the dumbing-down caused by the assumption that this advice, which is valid on any given day and hence idiotic, should require a nod from the stars.

The dependency and obedience of the people, the ultimate aim of the culture industry, could scarcely be more faithfully described than by the American test subject who opined that the hardships of the present day would come to an end if everyone simply followed famous personalities. In offering people vicarious satisfaction by

giving them the pleasant feeling that the world is in precisely the state of order in which it wants them to believe, the culture industry cheats them of the very happiness it fraudulently promises them. The overall effect of the culture industry is one of anti-enlightenment; in it, what Horkheimer and I called enlightenment, namely the increasing domination of nature through technology, becomes mass deception, a means of shackling consciousness. It prevents the formation of autonomous, independent individuals who judge and decide con-sciously; yet these are the perquisite for a democratic society, which can only survive and develop through the maturity of its members. If the masses are unjustly disdained from above as mere masses, it is not least the culture industry that turns them into the masses it then despises, and prevents them from attaining the emancipation for which people are as mature as the productive forces of the time allow.

# Obituary for an Organizer

When a dead person is referred to as irreplaceable, this is usually said to conceal the fact that they have already been replaced. The inwardness of the memory becomes a pretext for a hasty practice that passes over the deceased because life itself must go on. One could say that they are subjected for the second time, now socially, to the injustice that death means for every individual. Useful work can be done by others too; everyone agrees on this, and it is an indictment of the constitution of life and the concept of utility to which it submits. Yet someone truly irreplaceable is Wolfgang Steinecke, the first director of the International Music Institute and the International Summer Course in Darmstadt, and, I might add, the one whose strength, though he may not entirely have realized it, created something like a united musical movement after the Second World War. He was the exception: a person who achieved in the midst of the scene something that went far beyond the scene. He used the scene's own methods to lend art the seriousness that is destroyed by the scene. The only course of action after his death, unless one wants to cover it up with comforting platitudes, is to tell as many people as possible as clearly as possible who Wolfgang Steinecke was. This applies also to the respected person who killed him: they should at least know the harm done by their booziness. There is a startling logic in this: the music for which Steinecke lived bore no resemblance whatsoever to such a mood, and had the latter not won out, he need not have died.

The uniqueness of Steinecke's work and its effects is enclosed by the paradox that he played by the rules of musical life to achieve what was irreconcilable with them. With modest means, without the seal of celebrity or an attractive image for the festival, he created a crystallization point for New Music that is unparalleled anywhere in the world. He did not set up a platform, he did not organize music in the manner of an exhibition, simultaneously displaying everything available with foolish cunning; rather, he followed the most radical and daring intentions and enabled friction and exchange among those who had no other support, silently and discreetly allowing an idea to emerge that perhaps lay dormant and latent within numerous musicians of the post-war generation, but would never have taken on such force without him. If there has, for all the differences, been something like a school of uncompromising music since 1946 whose intransigence can bear comparison with the Second Viennese School of Schoenberg, then this was his achievement and his alone. No one else would have brought together all the unruly, obstinate and difficult people that belong to this school— and if they were less difficult, they would all have chosen the easier path—and kept them together, bypassing with imperceptible energy the more sluggish authorities that could initially not be avoided, and provided an atmosphere in which, even in the most heated conflicts, a common driving force could flourish in a state of solidarity. The school arose from such profound ways of reacting that what stirred there cannot, even to this day, be reduced to a single name. For the slogans emanating from Darmstadt—serial, pointillist, aleatory, post-serial, informal music—are often mutually irreconcilable. And yet there is a common impulse that lives in all of them, and Steinecke had an unerring intuition for teasing it out. Perhaps it was precisely because, as a member of an older generation, I did not myself feel animated directly by that impulse, which probably constitutes the unity of the Kranichstein or Darmstadt school, that I was in an

especially favourable position to notice it. Steinecke trusted me sufficiently to involve me on numerous occasions despite the generational difference, which is more than a merely chronological one, which brought me into contact with the most talented young musicians without any need for concessions on either side, and the contrasts instead became fruitful, if I am not mistaken; I am profoundly grateful to him for this.

Perhaps nothing shows more impressively the force exuded by Steinecke and his Darmstadt idea—for it was his, even though he never claimed it for himself—than the fact that each one of us clung passionately to the prospect of being invited as a tutor. The material aspect was insignificant, since he could only pay a modest fee. And yet we all had the impression, rightly or wrongly, that in Darmstadt—forgive the grand words—we were intervening directly in the formative processes of New Music. Not to be invited was a disappointment. This never proved a reason to fall out, however— perhaps this was the greatest achievement of the deceased. Not that he was willing or able to smooth the waters, as one says so readily in such cases; this would have been irreconcilable with his penchant for extremes. But he was so immune to attacks and reproaches that it never came to the kind of 'talks' after which one parts ways on bad terms.

The man's ingenuity was evident in the fact that quarrels were incompatible with his nature, yet he never made the slightest effort to avoid them. Attacks simply bounced off him. Taciturnity and shyness, which were undoubtedly native to him, had seemingly involuntarily been elevated to a life technique that had a certain Far Eastern quality. He listened to complaints and objections with a Buddha-like smile of which one could never be sure whether it was guileless or a protective mask, and which was probably a combination of the two—not to explain his behaviour, but to brush off the criticism with a few words. He engaged so little with the arguments

that his opponents were disarmed and possibly even felt that they were in the wrong.

Describing this makes it sound like a tactical recipe, yet anyone who sought to imitate it would be lost. Steinecke only got away with it because the tactic was not a tactic but rather an uncalculated way of behaving, a wordless gesture, perhaps as remote from language as the image of New Music he harboured. In reality he was as humane as he was unresponsive. If someone found themselves in serious difficulties, for example owing to illness, he helped them—again wordlessly and as a matter of course—with self-assured nobleness. Steinecke, who surpassed all the managers of the music world with the success of his truly utopian project, arousing the rancour of the talentless that are triggered by the word 'manager', was himself the opposite of one. He did what he was destined to do with gentle inertia; he never manipulated others, never misused people as things or means as ends; he was as devoid of all bias as any artist who resists the temptations of the world. Not only was he indifferent to personal advantages; he also withdrew to the point of anonymity in his intellectual involvement when everything hinged upon him. He avoided speaking in public, avoided letting it be known how much the entire Darmstadt school was his product; this makes it all the more of a duty to say publicly what he would surely not have tolerated in his lifetime.

How better to honour him than by pointing out that in spite of all this, his function, which did not exist until he created it and to which he was so incomparably well-suited, went beyond the good fortune responsible for the existence of a person of his specific quality. Rather, his achievement was objectively demanded by the state of music during the years in which he intervened. It was not least his intellectual contribution that proved that society brings forth the forces it requires for the fulfilment of its tasks. New Music, which from the start had been at odds with the official culture and

the artistic establishment, emerged from individualistic pathos and clearly individualistic conditions of production. At the time, protest against the hardening of social relations and the hardened culture in which they persist went together with protest against socialization itself, and against organization.

Admittedly, Schoenberg had recognized as early as 1920 that this protest cannot be realized artistically, in performance practice, unless it becomes something organizational itself; that is why he rounded the Vienna Society for Private Musical Performances, whose work remains the model for all true interpretation to this day. In the 45 years since then, the collectivization and administration of society, including musical life, has increased immeasurably; the concentration of musical performance in the mass media is only the most obvious expression of this. The old individualistic forms of musical life, including production, that is to say, composition, cannot possibly resist this pressure any longer, either in economic or technological terms. The entire set of problems relating to the issue of electronics, for example, requires an apparatus that is no longer available to any individual. The more seriously and radically people work with the new materials, the deeper the technological conditions extend into the production process. Even when the means of electronic sound production are not directly used, the laboratory character of composition is spreading as a result of immanent logic. The extreme formulation of the concept of experimentation, the rationalization of compositional techniques and the innate conflicts between them or the testing of chance procedures demand a form of collective cooperation of which Webern, the anchorite, and Berg, the late secessionist, would never have dreamt.

Outrage over this tendency, which is artistically irrevocable to the extent that it follows the development of society, can scarcely conceal the all-too-understandable outrage of those who are powerless before it on account of their own individualistic constitution

and social position. Because they fear growing old in the substantial historical sense too, they rail against the alleged superficialization, mechanization and management. Steinecke has precisely filled the cultural gap between the irresolvable element of artistic individualism—for art is social objection to society—and the inevitable collective forms of production. The social is the paradox of his work: the fact that he organized all those things that earnestly resist the cellophane world of musicals and light music, slick festivals and 'streamlining' for the purpose of musical tourism, in such a way that they could develop without concessions in the midst of the administered world. Where success supplants the quality of the matter itself, he broke through this principle and forced the success of what was unsuccessful a priori. He administered the unadministrable without corrupting it.

This reserved person, infinitely remote from any of the posturing, self-importance or ostentation so common today, had a sense of realism that might have made him the envy of the most assiduously self-promoting impresario. What he was really like, how a protégé of conservative musicology found his intellectual position, what personal qualities allowed him to transform it into a position of power in New Music—as he was so tight-lipped, only those very close to him will know that. There is truly something enigmatic about the phenomenon. It is no exaggeration to say that his tragic death is a disaster for music whose full consequences cannot yet be determined. The consolation that the authentic is preserved by posterity and prevails of its own accord has become spurious. Steinecke's work was not least a response to a situation in which precisely such a laissez-faire approach can no longer be relied on, in art as elsewhere.

To say that he changed the concept of musical productivity itself is merely another way of putting this; conventional language reserves this concept for the powers of the composer. Yet if the composer depends directly on institutions to be able to produce anything in

the first place, not only indirectly on the market that provides them with a living but on technical and organizational assistance, commissions, procedures that can no longer flourish in the isolation of their study, then musical productivity extends beyond writing music. One could already see something of this in Wagner's conception of Bayreuth, and Steinecke recognized the full implications of this. And yet he never exploited this expansion as one of decreeing power; he did less and more. Less, by never interfering with the functions of others in the strict division of labour, even when he was entirely responsible for enabling the compositional work; and more, by not simply providing the practical possibilities, but becoming involved even in the most intricate intellectual contexts in his utterly unobtrusive and restrained way through his human resource policy and programming, and also in private discussions.

If the venerable concept of artistic production no longer has the weight of former times, if it was debased by an alignment with industrial procedures in the name of profit, Steinecke saved the dignity of production in music. He brought together, forcefully yet gently, its socially and technically due form with its most advanced intellectual intention. The memory of this great organizer is that of a man who was the equal of the significant composers—not simply because he supported and sustained them, but because what he did is as essential to the new production process as what they wrote.

# Transparencies on Film

When playfully insulting one another, children follow a rule: no tit-for-tat. Their wisdom seems to be lost on the overly grown-up adults. When the people of Oberhausen attacked 60 years of film industry trash as 'Daddy's cinema', the industry's supporters could think of no better retort than 'Kids' cinema'. This tit-for-tat doesn't count, as children also say; it is pathetic to play off experience against immaturity when the attack is precisely aimed at the immaturity of the experience with which they broke their horns. What is abhorrent about Daddy's cinema is its infantility, its industrially driven regression. Sophistry insists on the kind of achievement whose concept demands opposition. But if there were something to the accusation, if the films that do not play along with the business were in some ways clumsier than its polished products, it would be a miserable triumph indeed that those with the power of capital, technical routine and highly trained specialists behind them are better at some things than those who rebel against the colossus, and are thus forced to dispense with the potential it has accumulated. The features of the comparatively awkward, inept work unsure of its effect are marked by the hope that the so-called mass media might become something qualitatively different. While, in autonomous art, nothing that lags behind a technical standard once that standard has been attained is adequate, there is, by comparison to the culture industry, whose standard excludes anything that has not already been pre-chewed and appropriated (much as the cosmetic branch eliminates the

wrinkles in people's faces) something liberating about works that do not show a full mastery of their methods, and thus let in a comfortingly uncontrolled chance element. In these, the imperfections in the complexion of a pretty girl become a corrective of the established star's flawless skin.

The *Törless* film,[1] as we know, uses large sections of Musil's early novel almost unchanged. One assumes them to be superior to the scriptwriter's lines, none of which would be spoken by a living person. In America, meanwhile, they were ridiculed by critics. But even the lines from Musil often sound wooden, in their own way, as soon as they are heard rather than read. The original novel bears a share of the responsibility for this, as it introduces—presumably as psychology—a form of rationalist casuistry into the development of inner feelings that the advanced psychology of the same period, namely Freud's, demolished as rationalization. That is hardly all, however. Evidently the artistic difference between the two media always weighs even more heavily than one believes when, to avoid bad prose, one adapts good prose. Even when the novel uses dialogue, the spoken word is not directly spoken but instead distanced through the gesture of narration, perhaps already through the typography, and removed from the corporeality of living persons. Thus the figures in a novel, no matter how meticulously described, are never identical to empirical ones, rather moving further away from empiricism through the precision of their characterization and becoming aesthetically autonomous. That distance is shrunk in film: in so far as it behaves realistically, the semblance of immediacy is essential. Thus lines that are justified by the principle of stylization in stories, where they distinguish themselves from the false ordinariness of reportage, sound bombastic and implausible in film. It must

---

1 *Young Törless*, Volker Schlöndorff's 1966 adaptation of Robert Musil's 1906 novel *The Confusions of Young Törless*. [Trans.]

find other means of immediacy. Improvisation, which intentionally submits to the fortuity of uncontrolled empiricism, may be one of the most suitable options.

The late genesis of film makes it difficult to distinguish between the two meanings of the technical as strictly as in music, where, until the advent of electronics, immanent technique—the coherent organization of the work—was separate from the means of reproduction. Film leads us to assert that the two are identical, for in film, as Benjamin pointed out, there is no original that is reproduced en masse; rather, the mass product is the matter itself. As in music, however, this identity is not automatically given. Connoisseurs of specific filming techniques point out that Chaplin did not have those possibilities at his disposal, or had no interest in them, and contented himself with photographing sketches, slapstick scenes or whatever. This does not lessen Chaplin's quality, and no one would deny that he is a purveyor of film. This enigmatic figure—how it resembled old-fashioned photographs from the first moment!—could not have developed his idea other than on the screen. It is impossible, then, to identify norms based on filming techniques as such. The most plausible type, the concentration on moving images,[2] is provocatively deactivated in such films as Antonioni's *La Notte*, though it is admittedly preserved in the stasis of such films as something negated. The anti-cinematic nature of the film gives it the power to express empty time, as if with hollow eyes. In its aesthetic, film will have to draw more on a subjective form of experience that it resembles, being indifferent to its own technological genesis, and which constitutes its artistic quality. Anyone who spends several weeks in the highlands after a year in the city, for example, and

---

2 See Siegfried Kracauer, *Theory of Film: The Redemption of Physical Reality* (Princeton, NJ: Princeton University Press, 1997), pp. 41ff.

abstains from all work, might unexpectedly experience colourful images of the landscape beneficently passing by in their sleep or half-sleep. They do not blend seamlessly into one another, however, but rather in a distinct sequence, as in the magic lantern of childhood. These pauses in the movement are what make the images of interior monologue similar to writing: in the same way, the latter is something that moves beneath the gaze and is simultaneously immobile in its individual signs. The relation of a procession of images to film is probably similar to that of the visual world to painting or the acoustic to music. Film would constitute art as an objectifying restoration of this mode of experience. The technical medium par excellence is deeply connected to natural beauty.

If one decides to take the self-examiners at their word, as it were, and confront the films with their context of effect, one will have to take a subtler approach than the older content analyses, which necessarily proceeded far too much from the intention of the films and neglected the breadth of variation between this and their effect. It is preformed in the matter itself, however. If, based on the thesis of 'television as ideology', different layers of behavioural models are superimposed, this implies that the official intended models, which constitute the ideology supplied by the industry, are by no means automatically the element that enters the viewer's mind; if empirical communications research finally set its sights on problems that lead somewhere, it would be worthwhile to focus on this one. The official models are overlaid with unofficial models that create the attraction and are deliberately undermined by the official ones. To catch customers and provide them with vicarious satisfaction, the unofficial— and heterodox, one might say—ideology must be presented far more broadly and juicily than is agreeable to the *fabula docet*;[3] the glossy

---

3 Latin for '(the) moral of the story (is)'. [Trans.]

magazines demonstrate this on a weekly basis. What is suppressed among the audience by taboos, namely the libido, reacts all the more promptly to this because the behavioural models introduce an element of collective approval by virtue of being allowed through at all. While the intention always opposes the playboy, the *dolce vita* and the wild parties, the opportunity to catch a glimpse of them is probably more pleasing than the zealous verdict. If one sees boys and girls everywhere—in Germany, in Prague, in conservative Switzerland, in Catholic Rome—walking through the streets locked in embrace, kissing unabashedly, they learnt this (and probably more) from the films flogged off as folklore by the Parisian libertines. When it seeks to grip the masses, even the ideology of the culture industry becomes as internally antagonistic as the society it targets. It contains the antidote to its own lie; this is all that need be pointed out to save it.

The photographic technique of film, primarily depictive, offers the object, which is alien to subjectivity, more individual validation than do aesthetically autonomous procedures; in the historical process of art, this is the retarding aspect of film. Even when it dissolves and modifies objects, as it is capable of doing, the dissolution is not complete. Therefore, it does not permit any absolute construction; the elements into which it is split retain the character of things, and are not pure attributes. On account of this difference, society extends into film far more directly from the position of the object than in advanced painting or literature. The irreducible quality of the objects in film is in itself a social sign; it does not become one only through the aesthetic realization of an intention. The aesthetic of film thus deals immanently, through its position in relation to the object, with society. There can be no aesthetics of film, not even a purely technological one, that does not incorporate its sociology. Kracauer's film theory demands what is missing from his book, which refrains from

overt sociology. Otherwise, anti-formalism changes into formalism. Kracauer plays ironically with his resolution from earliest childhood to celebrate film for discovering the beauties of everyday life; but this programme was an art nouveau programme, just as all the films that wish to let wandering clouds and darkened ponds speak for themselves are leftovers of art nouveau. Through their own choice of object, they insert into the object that is cleansed of subjective sense the very sense they seek to resist.

Benjamin did not address how deeply some of the categories he postulates for film—such as exhibition value or the test—conspire with the commodity character that his theory opposes. What is inseparable from all of them, however, is the reactionary nature of any aesthetic realism today, tending towards an affirmative reinforcement of the phenomenal surface of society, whose examination is rejected by realism as Romantic. Any meaning assigned to film by the camera eye, including a critical one, would be violating the law of the camera and blaspheming against Benjamin's taboo, which was formulated with the express intention of outdoing the cocky Brecht, and probably the secret one of thus freeing himself from him. Film is faced with the challenge of avoiding decorative art on the one hand while not descending into documentary on the other. The solution that presents itself most clearly is montage, like 40 years ago, which does not intervene in things but places them into text-like constellations. There is reason to doubt the durability of a procedure that aims for shock value. Pure montage, without the addition of intention in the details, refuses to adopt intentions merely on principle. It seems unrealistic to believe that the reproduced material as such could produce sense at the same time as avoiding all sense, especially psychological sense, as is suitable for its material. This entire question may have been rendered obsolete by the realization that refraining from bestowing sense, from any subjective supplement, is itself

a subjective act and thus bestows sense a priori. The subject that silences its existence says as much through that silence as when it speaks—and probably more. The method of the filmmakers derided as intellectual should internalize this in a second reflection. In spite of all this, however, the divergence between the most advanced tendencies in visual art and those in film persists and compromises even its boldest aims. Evidently its most fruitful potential is currently to be found in other media that are transformed into it, such as some music. The television film *Antithèse* by the composer Mauricio Kagel is one of the most powerful examples of this.

That films provide schemata for collective behaviours is not something that is only demanded of them additionally by ideology. Rather, collectivity extends to the innermost level of film. The movements it represents are mimetic impulses. The content and concept in particular animate the viewers and listeners to move along with them, as if in a procession. In this sense, film is similar to music, just as music resembled film in the early days of radio. It is hardly outlandish to refer to the constitutive subject of film as a 'we', for this is where its aesthetic and sociological aspects converge. A film from the 1930s, with the famous English folk actress Gracie Fields, was entitled *Anything Goes*; this id captures quite precisely and contentually the formal aspect of movement in the film, prior to any content. In being swept along, the eye finds itself in the current of all those who follow the same call. Admittedly, the indeterminacy of the collective id that accompanies the formal character of the film lends it the ideological misuse, this pseudo-revolutionarily blurred quality, that is announced verbally by the statement that things must change and gesturally by the fist being slammed on the table. Emancipated film would have to wrest its a priori collectivity from the unconscious and irrational context of effect, instead placing it in the service of the enlightening intention.

The technology of film developed a number of tools that run counter to its realism, which is inseparable from photography, such as blurred shots—corresponding to a decorative convention long obsolete in photography—dissolves and often also flashbacks. It is time to innervate the silliness of such effects and renounce them. The reason is that such means do not come from the necessities of each individual production, but rather from convention. They inform the viewer of what is meant here, or how they should supply what cannot be captured by film realism. As those means are almost always tied to certain expressive qualities, however, even if they have fallen out of use, a discrepancy develops between these and the established signs. This is what makes the inserts kitschy. Whether this continues in montage and in the incorporated associations outside the course of the film remains to be examined; such divagations would, at any rate, demand particular tact on the director's part. But the phenomenon offers a dialectical lesson, namely that technology, taken in isolation—that is, without considering the linguistic character of film—can contradict the latter's immanent laws. Emancipated film production should no longer rely uncritically, in the mode of a far-from-new objectivity, on technology, on the resources of the profession. For it is here that the concept of what is adequate to the material reaches its crisis before it has been properly obeyed. The demand for a meaningful relation between procedures, materials and import on the one hand and the fetishism of means on the other blend into a murky mixture.

It is undeniable that Daddy's cinema indeed corresponds to what the consumers want, or rather, that it provides them with an unconscious canon of what they do not want—namely, anything that is different from what they are fed. Otherwise, the culture industry would not have become masse culture, though the identical nature of the two is not as unquestionable as the critical mind thinks as long

as it remains on the side of production and neglects an empirical examination of reception. Nonetheless, the popular thesis among half-hearted and whole-hearted apologists that the culture industry is consumer art is untrue; it is the ideology of ideology. The mere blanket equation of the culture industry with the low art of all periods is useless. There is an element of rationality to the culture industry, of an intentional reproduction of the low, that was surely not absent from the low art of the distant past, but neither was it its calculable rule. In addition, the time-honoured crudeness and idiocy of the hybrids of *circenses* and farce that were popular in the Roman Empire do not justify rehashing such things once they had been aesthetically and socially discredited. But the claim of consumer art must be challenged even in the pure present, without regard for the historical dimension. It paints the connection between art and its reception in static-harmonistic terms, following the model—itself dubious—of supply and demand. Just as art cannot be imagined without relation to the objective spirit of its period, however, it also cannot be imagined without the element that goes beyond that spirit. The separation of art from the empirical reality that inheres in its constitution from the outset demands said element. That adaptation to the consumer which likes to declare itself humane, on the other hand, is economically no more than the technique for exploiting them. Artistically speaking, it means refraining from any interference in the viscous mass of the established idiom, and hence in the reified consciousness of the audience. By reproducing that consciousness with self-righteous devotion, the culture industry changes it all the more, namely in its sense: it prevents it from changing of its own accord, as it secretly wishes in a deep and unacknowledged layer of itself. The consumers are meant to remain just that: consumers. That is why the culture industry is not consumer art, but rather extends the will of those in control into their victims. The automatic self-reproduction of the existing order in its established forms is an expression of domination.

It will have been noticed that it is difficult, in the first moment, to distinguish the trailer for a forthcoming film from the main film one is awaiting. This says something about the main films. Like the trailers and the hit songs, they are advertisements for themselves, wearing the commodity character on their forehead as a mark of Cain. Every commercial film is really no more than a trailer for what it promises the viewer while cheating them of the same.

What a fine thing it would be if, in the current situation, one could say that the less artistically films present themselves, the more artistic they actually are. Looking at the snazzy class A pictures that the culture industry forces itself to produce for the sake of cultural representation, especially the psychological ones, one is inclined to do so. Yet one should beware of the optimism of defiance: the standardized Westerns and crime stories, to say nothing of German humour and idyllic tearjerkers, are even worse than the official top products. In an integral culture, one can no longer even rely on the dregs.

# Chaplin Times Two

## 1. Prophesied by Kierkegaard

In one of his earlier pseudonymous texts, *Repetition*, Kierkegaard closely examines farce, in keeping with a conviction that often leads him to rummage through the waste products of art in search of what eludes the aims of its great, cohesive works. There he speaks about the old Friedrichstadt Theatre in Berlin and describes a comedian by the name of Beckmann, whose picture he evokes with the tender fidelity of the daguerreotype in what could be a quotation of the later Chaplin. He says:

> He does not just walk, he *comes walking*. To come walking is something completely different, and with this ingenious action he sets the whole scene. He does not just represent an itinerant apprentice lad, he can walk into a scene as this character in such a way that one experiences everything. One glimpses the smiling village from the dust of the country road, hears the sounds of its peaceful activity, sees the footpath that runs down along the pond and how it swings off by the blacksmith's shop, when one sees B. come walking with a little bundle on his back, his staff in his hand, carefree and indefatigable.[1]

---

1 Søren Kierkegaard, *Repetition and Philosophical Crumbs* (M. G. Piety trans.) (Oxford: Oxford University Press, 2009), p. 32.

This figure who comes walking is Chaplin, who brushes against the world like a slow meteor, and the imaginary landscape he brings with him is the meteor's aura, which gathers itself into a transparent peace amid the quiet noise of the village, while he walks on with his cane and hat, which look good on him. The invisible train of street urchins is that of the comet, which is cleft by the earth almost without noticing. But if one recalls the scene in *The Gold Rush* in which Chaplin comes walking to the gold-diggers' village like a ghostly photograph in a living film, and disappears crawling into the hut, it is as if his figure, suddenly recognized by Kierkegaard, appears as a decorative prop inhabiting the urban landscape of 1840, from whose background the star now finally separated.

## 2. In Malibu

That profundity is irritated by profound objects, that it prefers, as Benjamin formulated it, to attach itself to the intentionless, would be something positive if it did not run riot in such a self-satisfied manner, uninhibited in relation to the object. It mostly uses the unexhausted objects as a pretext for something uncommitted and banal, exploiting the seeming lack of resistance from something that provides no meanings of its own and possibly, depending on its immediate character, itself tends towards banality or silliness, like the empty concepts to which the clever spirit reduces it. The liaison between spirit and clown is as understandable as it is unfortunate. There is no demonology that the children's darling was spared; one owes it to him first of all to recognize the laughter he arouses, before burdening him with the frippery of great categories that hang more loosely around him, and less amusingly so, than his traditional garb. At the very least, he should be granted a comprehensive period of grace.

Psychoanalysis seeks to relate the figure of the clown to reactions in earliest childhood, prior to the crystallization of a fixed ego. Whatever the truth of this, one could certainly seek a better understanding of the clown among children, who communicate with his image as mysteriously as with animals, than in the meaning of his behaviour, which denies meaning. Only a person who understood the near-senseless language shared by the clown and the children would understand him, in whom nature bids a shock-like farewell on the run, like the old man in the illustration 'Goodbye to Winter'[2]—nature, pushed out as mercilessly by the process of growing up, as that language is irretrievable for the adults.

The loss of this language demands silence in the face of Chaplin above all others. For his precedence over the other clowns, among whom he proudly counts himself—as far as I know, their club is the only one to which he belongs—induces interpretations that are all the more unfair to him the more they elevate him; thus they move away from the irresolvable whose resolution would be the only task for an interpretation of Chaplin that would be worthy of him.

I do not wish to violate this. It is only because I knew him many years ago that I will offer two or three observations, without any claim to philosophical substance, that could perhaps contribute to the *écriture* of his picture. We know how much the appearance of Chaplin the private person differs from that of the vagabond on the film screen. This does not relate merely to the well-groomed elegance that he in turn parodies as the clown, but rather the expression, which has nothing to do with the sympathy-seeking, abandoned and tear-proof victim. Rather, his forceful, abrupt and quick-witted mobility recalls a predator poised to pounce. Only through this animal quality could earliest childhood preserve itself in an attentive life. Something about

---

2 A nineteenth-century springtime children's song ('Winterade') by August Heinrich Hoffmann von Fallersleben. [Trans.]

the empirical Chaplin suggests that he is not a victim but rather seeks victims, pounces on them, tears them apart: threatening. One could easily imagine that his inscrutable dimension, that which makes the most perfect clown more than his genre, is connected to this: that he projects his violent and dominant quality onto his surroundings, as it were, and that only this projection of his own guilt creates the innocence that lends him a greater violence than is possessed by any violence. A Bengal Tiger as a vegetarian: he is comforting, because the goodness that is cheered on by the children has been bargained away from evil, which sought to destroy him in vain because he had already destroyed it in his own image.

Quick-wittedness and omnipresence of acting ability are also attributes of the empirical Chaplin. It is well-known that he does not save his acting skills for his films, which, since his youth, he has only produced at long intervals and evidently highly self-critically. He is constantly acting, like Kafka's trapeze artist who sleeps in a luggage net to ensure that he does not miss a moment of training. Any time spent in his company is an uninterrupted performance. One scarcely dares speak to him—not for being in awe of his fame, for no one could make less of it, no one could be more unpretentious than he— but for fear of disturbing the performance and thus breaking the spell. It is as if he were returning adult, purposeful life, the principle of rationality itself, back to mimetic behaviours and thus reconciling it. Yet this lends his corporeal existence an imaginary quality beyond the official art forms. If the private person lacks the features of the famous clown, as if the latter were taboo, he is all the more reminiscent of the juggler. A Rastelli[3] of mime, he plays with the countless bundles of his pure possibility, bringing their restless circling motions together to form a fabric that has as little to do with the causal world as cloud-cuckoo-land with the gravity of Newtonian

---

3 Enrico Rastelli (1896–1931) was a famous Italian juggler. [Trans.]

physics. Incessant and involuntary transformation: with Chaplin, that is the utopia of an existence freed from the burden of being oneself. His ladykiller was schizophrenic.

That I am speaking of him can perhaps be justified with a privilege that was granted to me entirely unearned: he imitated me. I am certainly one of only a few intellectuals to whom this happened, and who are capable of recounting that moment. We, along with many other people, had been invited to a villa in Malibu, at a beach just outside of Los Angeles. One of the guests bade farewell early while Chaplin was standing next to me. Unlike Chaplin, I extended my hand to him somewhat absent-mindedly, and I instantly recoiled: the departing guest had been one of the leading actors in the film *The Best Years of Our Life*, which became famous shortly after the war. He had lost a hand in the war, and in its place was a claw that was made of iron, but quite practical. When I shook his right hand and it even pressed mine in response, I was extremely startled, but knew at once that I must not reveal my shock to the injured man at any cost. So, in a fraction of a second, I transformed my expression of horror into an obliging grimace that must have been far more terrible. The actor had barely left before Chaplin began re-enacting the scene. So close to horror is all the laughter he brings people, and this proximity alone makes it legitimate and redemptive. I offer my memory of this, and my thanks, as my congratulations on his 75th birthday.

# Theses on the Sociology of Art

*For Rolf Tiedemann*

## 1

Based on its name, the sociology of art encompasses all aspects of the relationship between art and society. It is impossible to restrict it to a single one, such as the social effect of art works, for this effect is itself only one aspect of the totality of that relationship. To isolate it and declare it the only worthy object of the sociology of art would mean replacing its factual interest, which evades any premature definition, with methodological preference, namely for the procedures of empirical social research with which one claims one can determine and quantify the reception of works. A dogmatic restriction to this sector would, however, endanger precisely the objective knowledge in whose name its monopoly is asserted, since the effects of art works—and spiritual products as such—are not something absolute or final that can be adequately determined based on the recipients. Rather, their effects depend on countless mechanisms of distribution, social control and authority and finally societal structure in which contexts of effect can be established, as well as the socially conditioned state of consciousness and unconsciousness of those who are the objects of the effect. In America, this has long since been recognized in empirical social research. Paul F. Lazarsfeld, for example, one of its most renowned and resolute exponents, included two studies in the book *Radio Research I* that expressly dealt with

questions of determining those mass effects that, if I have understood the polemical intention of Alphons Silbermann correctly, are supposedly the only legitimate area of the sociology of music, namely 'plugging'—that is, the intensive advertising that turns songs into hits—as well as certain structural problems in music itself whose relation to the effect is complex and subject to historical change. The relevant deliberations can now be found in the chapter 'On the Musical Use of Radio' in my book *The Faithful Répétiteur.* The sociology of music would fall behind the standard that has already been reached, especially in American research, if it failed to acknowledge such questions as valid.

# 2

I feel quite misunderstood when people view my music-sociological publications since returning from emigration as opposed to empirical social research. I would like to emphasize forcefully that I consider these methods not only important but also appropriate within their sector. The entire production of the so-called mass media is tailored a priori to empirical methods, whose results are in turn used by the mass media. The close connection between the latter and empirical social research is well-known: the current president of CBS, one of the largest American commercial radio companies, was director of research there before taking on his current position. I think, however, that the simplest common sense, by no means only philosophical reflection, demands placing inquiries of the survey type in the correct context if they are genuinely to offer social insights, not merely information for interested parties. Silbermann demands this too, and follows on from René König in speaking of the analytical function of the sociology of art. Lazarsfeld, agreeing with him, referred to this at the time as critical communication

research, in contrast to a merely administrative kind. The concept of 'art experience', which Silbermann thought should be the sole object of the sociology of art, presents problems that can only be solved by examining the matter respectively being 'experienced' and the conditions of its dissemination; only such a context can bestow any value on surveys. So-called art experience, which is central neither for cultural consumers nor for the competent, is extremely difficult to pinpoint; it is highly diffuse except in the case of true experts. For many people, it resists verbalization. Furthermore, considering the mass communications that form an entire system of stimuli, it is less a matter of individual experiences than the cumulative effect. 'Art experiences' only apply in relation to their objects; their meaning can only be ascertained in their confrontation with the latter. They are only seemingly something primary, being in reality a result; they emerge from an infinite number of processes. Problems such as the adequacy or inadequacy of 'art experiences' in relation to their objects, as raised by the mass reception of art works categorized as classics, problems that are clearly of the greatest sociological relevance, cannot be grasped at all through merely subjectively oriented methods. The art-sociological ideal would be to coordinate objective analyses—that is, analyses of the works—with those of the structural and specific mechanisms of effect, as well as the measurable subjective findings. They should be mutually illuminating.

# 3

The question of whether art and anything that refers to it is a social phenomenon is itself a sociological problem. There are art works of the highest dignity that have no great social significance, at least according to the criteria of their quantitative effect, and which would therefore, according to Silbermann, not merit examination. This

would lead to an impoverishment of the sociology of art, however: works of the highest standard would fall through the cracks. If they do *not* attain any notable social effect, in spite of their quality, then this is as much a *fait social* as the opposite case. The social import of art works sometimes lies precisely in *protesting* against social reception, for example in relation to conventional and hardened forms of consciousness; from a historical threshold located in the middle of the nineteenth century onwards, this is virtually the norm for autonomous works. A sociology of art that neglected this would turn itself into a mere technique to be used by agencies seeking to calculate what gives them the best chances of recruiting customers.

## 4

The latent axiom of the view that seeks to confine the sociology of art to measuring effects is that works of art are no more than people's subjective reflexes to them. For this scientific position, they are purely stimuli. For the most part, this model applies to the mass media, which aim for effects and are modelled according to presumptive effects in keeping with the ideological aims of the planners. This does not apply universally, however; autonomous works of art follow their own immanent law, the principle that organizes them as meaningful and coherent. The intention as to their effect may be secondary. Their relationship to those objective elements is complex and often varies, yet it is certainly not the be-all and end-all of the works. These are themselves something spiritual; they are knowable and definable in their spiritual composition, not the unqualified, as it were unknown and un-analysable causes of bundles of reflexes. There is incomparably more to be found in them than can be ascertained with a procedure that seeks to leave aside the objectivity and import of the works. It is precisely this excluded element that has

social implications, which is why the spiritual definition of the works must be incorporated, whether positively or negatively, in the treatment of the contexts of effect. As works of art are subject to a different logic from that of concept, judgement and conclusion, a shadow of relativity clings to the recognition of objective artistic import. It is such a long way from this relativity at the highest level to the fundamental denial of an objective import as such, however, that one can view the difference between them as all-important. After all, we may find it very difficult to elaborate the objective import of a late Beethoven quartet in thought; but the difference between this import and that of a hit song can be identified in very clear, largely technical categories. The irrationality of art works is usually considered much higher by the inartistic than by those who personally engage with the discipline of the works and have some understanding of them. The definable aspects also include the immanent social import of the works, such as Beethoven's relationship to bourgeois autonomy, freedom and subjectivity, extending to his compositional methods. This social import, even if it is unconscious, is a ferment of effect. If the sociology of art shows disinterest towards it, it fails to recognize the deepest relationships between art and society: those that crystallize in the works themselves.

5

That also concerns the question of artistic quality. This question is first of all open to sociological examination as, simply put, the question of the adequacy of aesthetic means for aesthetic ends, their coherence, but then also the adequacy of the ends themselves—be it the manipulation of customers or something intellectually objective. Even if this examination does not engage directly in such critical analysis, it still requires it as its own precondition. The postulate of

so-called value-freedom offers no dispensation from this. The entire discussion about value-freedom, which some are now attempting to revive and even turn into the decisive point of controversy in sociology, is obsolete. On the one hand, one cannot look for free-floating values that exist beyond social interrelations, as it were, or beyond manifestations of the spirit; this would be dogmatic and naive. The concept of value is itself an expression of a situation in which an awareness of intellectual objectivity has been watered down. It was arbitrarily reified in retaliation for crude relativism. On the other hand, any artistic experience, and in fact any simple judgement of predicative logic, presupposes critique so fundamentally that abstracting from this would be as arbitrary and abstract as a hypostasis of values. Division into values and value-freedom is an idea from above. Both concepts bear the mark of a false consciousness: the irrational, dogmatic hypostasis as much as the neutralizing one, whose abstention from judgement constitutes an equally irrational acceptance of what is the case. A sociology of art that submitted to the authority of Max Weber's postulate, which he himself greatly qualified as soon as he became a sociologist rather than a methodologist, would be unproductive despite all its pragmatism. Precisely through its neutrality, it would find itself in extremely questionable contexts of effect, unwittingly serving powerful interests that would then be allowed to decide what is good and what is bad.

# 6

Silbermann espouses the view that one of the tasks of the sociology of art is to have a socio-critical effect.[1] It strikes me as impossible to live up to this desideratum, however, if the import and quality of

---

1 Alphons Silbermann, 'Kunst' (encyclopedia entry) in René König (ed.), *Soziologie* (Frankfurt: S. Fischer, 1958), p. 165.

the works are taken out of the equation. Value-freedom and socio-critical function are irreconcilable; it then becomes impossible either to make meaningful statements about the social consequences of specific communications that are to be expected, and thus criticized, or to decide what should or should not be disseminated in the first place. The social effect of the works becomes the only criterion, a simplistic tautology. It inevitably means that the sociology of art must follow the status quo in its recommendations and abstain from the very kind of social critique whose necessity Silbermann by no means disputes. As far as I can tell, drawing up so-called 'culture charts' for planning radio programmes, for example, would merely lead to a description of prevailing communications relations without opening up any critical possibilities. Instead, it would favour precisely the dominant alignment of media and people that autonomous insight must resist. Furthermore, it is doubtful whether the concept of culture itself is accessible to the type of analysis propagated by Silbermann. Culture is the condition that rules out attempts to measure it. Measured culture is already something entirely different, an inclusive concept of stimuli and information that is incompatible with the concept of culture. This makes it clear how unfeasible is the elimination of the philosophical dimension in philosophy demanded by Silbermann and others. Sociology emerged from philosophy; if it is not to become entirely conceptless, it still requires the type of reflection and speculation that came about in philosophy. After all, the quantitative results even of statistical inquiries, as the science of statistics meanwhile underlines, are not an end in themselves, but rather serve the purpose of revealing something sociological. This 'revealing', however, in the sense of Silbermann's distinction, would fall very much under the category of the philosophical. The division of labour between disciplines such as philosophy, sociology, psychology and history is not based on their subject matter, but rather imposed on it from without. A science that truly lives up to the

name, one that is not naively flippant but self-reflective, cannot respect a division of labour that is incidental to the subject matter: this is also something that is being acted on in America. The demand for interdisciplinary methods applies especially to sociology, which, in a certain sense, encompasses every possible object of examination. As social consciousness, it should seek to redress something of the social injustice that has been done to the consciousness by the division of labour. It is no coincidence that almost all sociologists visible in Germany today come from philosophy, including those who are most bitterly opposed to philosophy. Right now, in the sociological debate on positivism, the philosophical dimension is being drawn into sociology.

# 7

Finally, a note on the terminology: what I referred to in my *Introduction to the Sociology of Music* as mediation is not, as Silbermann assumes, the same as communication. I used the concept of mediation strictly in the Hegelian sense, without any attempt to deny this philosophical aspect. According to Hegel, mediation occurs within the matter itself, not between the matter and those to whom it is presented. Only the latter, however, is understood as communication. In other words, I mean the very specific question, aimed at the products of the spirit, of how structural aspects of society, positions, ideologies and whatever else assert themselves in the art works themselves. I unequivocally underlined the extraordinary difficulty of the problem, and thus of a sociology of music that does not content itself with superficial classifications, with asking how art stands in society, how it acts within it, but seeks to understand how society objectifies itself in the art works. The question of communication, which—viewed critically—I consider as relevant as Silbermann does,

is quite different from this. In communication, however, one should not only consider what is offered each time and what is not communicated, nor merely how reception occurs; this is a problem of qualitative differentiation, something whose difficulties can only be imagined if one has seriously attempted to describe listeners' reactions precisely. A central part of this is *what* is communicated. Perhaps I might explain this by recalling my question of whether a symphony that is disseminated on the radio, and possibly repeated ad nauseam, is actually the same symphony of which the dominant view is that the radio gave it to millions. This in turn raises far-reaching education-sociological consequences—for example, whether the mass dissemination of some art works genuinely possesses the education function that is ascribed to it; whether, under the current conditions of communication, the type of experience tacitly meant by artistic education comes about at all. The dispute about the sociology of art is directly relevant to the sociology of education.

# Functionalism Today

As grateful as I am for the trust shown by Adolf Arndt in inviting me to speak to you, I have equally serious doubts as to whether I truly have the right to do so. Professionalism and expertise in matters of craft and technique count for a great deal among you, and rightly so. If there is an idea that has survived in the Werkbund movement,[1] it is that of concrete areas of responsibility as opposed to an unfettered aesthetic that is remote from material. From the perspective of my own profession, that of music, I consider the need for this demand self-evident, thanks to a school that had close personal connections to both Adolf Loos and the Bauhaus and saw an intellectual kinship with the striving for objectivity in many respects. I cannot, however, claim to have the slightest competence in matters of architecture. The fact that I nonetheless succumbed to the temptation, exposing myself to the danger of being tolerated and dismissed as an amateur, I can at least fall back—aside from the fact that I am happy to present a few reflections to you in particular—on Adolf Loos's view that a work of art has no obligation to be liked, but a house is responsible to everyone.[2] I do not know if this

---

1 The Deutscher Werkbund is a German association of artists, architects, designers and industrialists that was founded in 1907 and was later significant for the Bauhaus school. [Trans.]

2 Adolf Loos, *Gesammelte Schriften* (Adolf Opel ed.) (Vienna: Lesethek, 2010), p. 401; translated by the present translator.

statement is correct, but I need hardly be more Catholic than the pope. The discomfort that overcomes me when I look at the German reconstruction style, which I am sure many of you share, leads me— since I am exposed to the sight of such buildings no less than an expert—to ask why this is so. The commonalities between architecture and music have long since been described in snappy formulations repeated ad nauseam. Perhaps, in bringing together what I see with what I know about the difficulties of music, I am not speaking from as uninvolved a position as the rules affecting the division of labour might suggest. In so doing, I must adopt a greater distance than you would rightly expect. I do not consider it entirely impossible, however, that there is sometimes—in situations of latent crisis—something to be gained from viewing phenomena from a greater distance than the pathos of technical jurisdiction would tolerate. Doing justice to the material is based on division of labour, but this also means that experts should occasionally consider how much their expertise suffers because of that division, and how much the necessary artistic naiveté can become a barrier to itself.

Let me proceed from the observation that the anti-ornamental movement has also affected the absolute arts. To ask what is necessary in works of art and resist what is superfluous is based on the works themselves. Now that tradition no longer provides the arts with a canon determining what is right and wrong, each work is burdened with such reflection; each one must examine its own immanent logic, whether this is driven by an external purpose or not. This is far from new; Mozart, who was truly a carrier and critical executor of a great tradition, responded to a potentate's gentle rebuke after the premiere of *Die Entführung aus dem Serail*, 'But there were a great many notes, dear Mozart', with the words 'Not one more than necessary, Your Majesty'. In the *Critique of the Power of Judgement*, Kant philosophically articulated this norm in the principle of purposiveness without purpose as an aspect of the judgement of taste.

Yet it contains a historical dynamic: something that still identified itself as necessary in the given language of an area of material becomes superfluous, indeed ornamental in the bad sense, as soon as it ceases to legitimize itself in that language, in what one usually calls style. What was functional yesterday can turn into the opposite; this historical dynamic in the concept of the ornament was very much retained by Loos. Even something representative, luxuriant, opulent and, in a sense, tacked on, may in some types of art be necessary based on its own principles, not tacked on; to condemn the Baroque for such reasons would be philistine. Criticism of the ornament amounts to criticism of that which has lost its functional and symbolic sense, and is left over as something rottenly organic and poisonous. All new art opposes this: the fictitiousness of run-down Romanticism, the ornament that can now only invoke itself with shameful impotence. Such ornaments have been expunged from the new music organized solely according to expression and construction no less rigorously than from architecture; the compositional innovations of Schoenberg, the literary struggle of Karl Kraus against newspaper catchphrases and the denunciation of the ornament by Loos are by no means related via some vague intellectual-historical analogy, but have exactly the same meaning. This leads me to a correction of Loos's claim that, generous as he was, he would not have rejected, namely that the question of functionalism does not coincide with that of practical function. The purpose-free and purpose-bound arts are not as radically opposed as he alleged; the difference between the necessary and the superfluous inheres in the works, and is not determined merely by their relation to something external or the lack thereof.

In the work of Loos and the early functionalists, the purpose-bound and the aesthetically autonomous are separated via decree. This separation, which calls for renewed reflection, found its polemical target in the decorative arts. Loos came from this era; he

escaped from those arts, historically located somehow between Peter Altenberg and Le Corbusier. The movement that, from Ruskin and Morris onwards, rebelled against the monstrosity of mass-produced, yet simultaneously pseudo-individualized forms and gave rise to such concepts as stylistic will, stylization or design; the idea that one should bring art into life in order to cure it, that one should apply art, and all other similar slogans. Loos sensed the questionable nature of such efforts early on: it is an injustice towards objects of utility to infuse them with something that is not demanded by their function, and an injustice towards art, that undaunted protest against the subordination of humans to purposes, if it is reduced to the very practice to which, according to Hölderlin, it objects: 'For nevermore will the sacred / be suitable for use'. An inartistic artification of practical objects was as abhorrent as the orientation of purpose-free art towards a practice that would ultimately have subjected it to the omnipotence of profit, something the decorative artistic tendencies had resisted, at least in their early phase. Loos, by contrast, preached a return to a decent handicraft[3] that makes use of technical innovations without borrowing forms from art. His demands, whose restorative element scarcely became less clear than the element of decorative-art individualization had before then, suffer from the overly plain dichotomy; they burden discussions of objectivity to this day.

Purpose-free and purpose-bound elements in the works should therefore not be separated absolutely because of their historical intertwinement. After all, it is well-known that the ornaments which Loos despised, with a berserker's rage that is strangely incongruent with his humanity, are often the scars of outdated production methods borne by the objects. Conversely, purpose-free art has

---

3 While the German *Handwerk* is translated elsewhere as 'craft', Adorno's later reference to the composition of the word *Handwerk* necessitated the use of the closer cognate 'handicraft'. [Trans.]

seen the inclusion of purposes such as conviviality, dance and enter-tainment, which ultimately disappeared within its formal law. Purposiveness without purpose is the sublimation of purposes. The aesthetic does not exist as such, only as the area of tension in such sublimation. By the same token, however, there is no chemically pure purposiveness that constitutes the opposite of the aesthetic. Even the purest functional forms draw on such notions as formal transpar-ency and comprehensibility that come from artistic experience; no form is created exclusively from its purpose. It is ironic that in one of Schoenberg's revolutionary works, of which Loos spoke with great insight, the First Chamber Symphony, there is a theme of an orna-mental character with a turn[4] that recalls one of the main motifs in *Götterdämmerung* as well as a theme from the first movement of Bruckner's Seventh Symphony. The ornament is the idea that carries it; it is itself objective, one might say. It is precisely this transitional theme that becomes the model for a canonical development section in four-part counterpart, the first extremely constructivist complex in the new music. The faith in a material as such was adopted from the religion of the decorative arts, the belief in allegedly pure raw materials; it still haunts autonomous art. The idea of material-appropriate construction followed on from this. It corresponds to an undialectical concept of beauty that fences in autonomous art as a nature reserve. If Loos's hatred of the ornament were consistent, it would have to be extended to all art; once art has attained autonomy, it cannot purge itself completely of ornamental elements, since its own existence, according to the criteria of the practical world, would be ornamental. To his credit, Loos stops short of this conclusion— like the positivists, incidentally, who seek to expunge from philos-ophy anything resembling poetry in their eyes, yet do not consider poetry as such an impairment of their form of positivity; rather, they

---

4 A turn is a musical ornament in which a notated main note alternates with the notes directly above and below it. [Trans.]

tolerate it within its own special area in a neutralized, yet uncontested form, having watered down the idea of objective truth as such.

The principle that the material carries its adequate form within itself presupposes that, as such, it is already invested with sense in the same way it once was by the symbolist aesthetic. Resistance to the nuisance of the decorative arts has long ceased to apply only to borrowed forms; it applies more to the cult of materials that places an aura of essence around them. Loos expressed this in his criticism of batik cloths. The synthetic materials invented since then— materials of industrial origin—no longer permit an archaic trust in their inherent beauty, a rudiment of the magic of precious stones. Not least, the crisis in the recent developments in autonomous art shows how little can be gained from the material as such in the way of meaningful organization, and how easily such attempts approach empty tinkering; the notions of what is appropriate to the material in applied art are not indifferent to such critical experiences. The illusory aspect of purposiveness as an end itself is revealed by the most basic social reflection. Something can only be purposive in the here and now if it is purposive in current society. However, Irrationalities are inherent in this society—what Marx called its *faux frais*[5]—because, at its innermost level, despite all planning of particularities, the social process still takes place in an aimless, irrational fashion. Such irrationality imprints itself on all ends, and hence on the rationality of the means that are meant to achieve those ends. Thus the ubiquitous advertising, which is purposive for profit, defies all purposiveness when judged by its appropriateness to the material: if it were functional, without any ornamental surplus, it would no longer serve its purpose as advertising. To be sure, horror at technology is stuffy and reactionary, but that is not all it is. It is also a shudder at the violence that an irrational society inflicts on its forced members and on all that is. In it

---

5 French for 'incidental operating expenses'. [Trans.]

we find the continued tremor of a childhood experience that seems to have been alien to Loos, despite the saturation with early experiences he displays elsewhere: a longing for the castle with long series of rooms and silk wall coverings, the utopia of having escaped. Something of this utopia lives on in the disgust for walkways, for the kitchen celebrated by Loos, for the factory chimney, for the sordid side of an antagonistic society. It is idealized by semblance. Yet its dismantling, the demolition of the turrets of false knight's castles ridiculed by Thorstein Veblen and of the embossed ornaments on people's shoes, has no power over what is debased in the sphere in which practice still occurs; rather, it may increase the horror. This also has consequences for the world of images: positivist art, a culture of the merely existent, was confused with aesthetic truth. The prospect of a neo-Ackerstrasse[6] is on the horizon.

To this day, the limit of functionalism is bourgeois culture as practical sense. In Loos, the avowed enemy of Viennese fried chicken culture, one finds astonishingly bourgeois aspects. In his city, the bourgeois fabric was still so pervaded by feudal-absolutist forms that he wanted to ally himself with the latter's rigorous principle in order to emancipate himself from the world of archaic formulas; his writings contain invectives against the circuitously curial Viennese politeness, for example. Beyond this, however, his polemic has an oddly puritan tinge; it is akin to obsession. As in much bourgeois cultural critique, one finds in Loos an overlap of two aspects: the insight that this culture is not yet a culture that would guide him to advance in his relationship with his native milieu, and an anti-cultural element that would like to forbid not only all semblance, but also the gentle, smoothing hand, untroubled by the fact that neither rough nature nor the unmerciful control over it have a place in culture. The future

---

6 Ackerstrasse is a major street in Berlin; one part of it was on the border strip while the city was divided. [Trans.]

of objectivity, then, only promises freedom if it eschews barbaric intervention, no longer subjecting human beings, whose needs it proclaims as its guiding principle, to sadistic blows through sharp edges, starkly calculated rooms, stairs and the like. Almost every consumer will have experienced first-hand the painfully impractical nature of the mercilessly practical; hence the suspicion that what rejects style is unconsciously itself a style. Loos traces ornaments back to erotic symbols. The demand to abolish them is tied to his aversion to erotic symbolism; for him, untouched nature is regressive and embarrassing at once. The tone in which he condemns the ornament is reminiscent of the—often projective—outrage over sex offenders: 'But the person of our time who defaces walls with erotic symbols is a criminal or a degenerate.'[7] The slur of degeneracy takes Loos into areas he would have found unwelcome. 'One can,' he opines, 'measure a country's culture by how defaced its toilet walls are.'[8] Yet one will find a great deal of this in southern countries and Romance countries in general; the surrealists saw a certain value in such unconscious acts, and Loos would surely have hesitated to accuse such regions of a lack of culture. His hatred of the ornament would be incomprehensible if he did not sense in it the mimetic impulse that runs counter to rational objectification; expression, related even as sorrow and lament to the pleasure principle that denies their expression. It is only schematically that the expressive element can be relegated to art and split off from objects of use; even where it is absent from these, they pay tribute to it through their effort to avoid it. Obsolete everyday objects fully become expression, a collective picture of the period. There is scarcely a practical form that is not, alongside its practical suitability, also a symbol. Psychoanalysis revealed this in the archaic images of the unconscious, of which the

---

7 Loos, *Gesammelte Schriften*, p. 364.
8 Loos, *Gesammelte Schriften*, p. 364.

house is the most important, and Freud showed that symbolic inten-
tion swiftly attaches itself to technological forms such as the airship;
according to American research in the field of contemporary mass
psychology, this applies especially to cars. Functional forms are the
language of their own function. Through the mimetic impulse, the
living makes itself identical to its surroundings long before artists
begin their imitation; whatever seems to be symbolic, then ornamen-
tal and finally superfluous originates from natural shapes to which
humans adapt through their artefacts. The interiority they express in
that impulse was once an exteriority, something compellingly objec-
tive. This would explain the fact, known since Loos, that ornaments—
and also artistic forms as such—cannot be invented. The achievement
of every artist, not only those bound to purposes, is reduced to some-
thing incomparably more modest than what the art religion of the
nineteenth and early twentieth century sought. This does not, how-
ever, answer the question of how an art is at all possible in which
ornaments are not substantial and cannot be invented.

The trouble in which objectivity found itself is not a fault that
needs to be corrected in some way or other; it follows from the his-
torical direction of the matter. Practical use, which is far more
directly related to the pleasure principle than constructs that answer
only to their own formal laws, involves a denial: it must not be.
According to the bourgeois work ethic, pleasure is wasted energy.
Loos adopted this view. His formulation shows how far the early cul-
tural critic conspired with the very order whose manifestations he
rebuked when they were still lagging behind their own principle:
'The ornament is wasted manpower and thus wasted health. It has
always been thus. But today it also means wasted material, and both
things mean wasted capital.'[9]

---

9 Loos, *Gesammelte Schriften*, p. 368.

Two irreconcilable motives intersect here: parsimony—for where, if not among the norms of profitability, is it written that nothing should be wasted—and the dream of a technified world liberated from the ignominy of labour. The second of these points beyond the world of uses. In Loos's thinking, it appears clearly in the insight that the much-lamented powerlessness to create the ornament, the so-called dwindling of stylistically formative power that he recognized as an invention of art historians, is a better option; that what bourgeois thinking habits consider negative about industrial society is actually its positive element:

By style, people meant the ornament. And I said, 'Weep not! Behold, this is what makes our time great, the fact that it is not capable of bringing forth a new ornament. We have overcome the ornament, we have brought ourselves to dispense with the ornament. Behold, the time is near, fulfilment awaits us. Soon the streets of the cities will shine like white walls. Like Zion, the holy city, the capital of heaven. Then fulfilment will be here.'[10]

The ornamentless state would then be one with utopia, the corporeally fulfilled present, with no more need for any symbol. The full truth of the objective inheres in this utopia. For Loos, it is assured through critical experience with art nouveau:

The individual human, and hence also the architect, is incapable of creating a form. But the architect attempts this impossible task over and over again—and each time with negative success. The form or the ornament are the result of unconscious collective work by the people of an entire cultural area. Everything else is art. Art is the self-will of the genius. God gave him this mission.[11]

10 Loos, *Gesammelte Schriften*, p. 365.
11 Loos, *Gesammelte Schriften*, p. 599.

Since then, the axiom that the artist acts at God's behest is no longer tenable. The disenchantment that began in the functional sphere has spread to art. Not least, the absolute difference between the mercilessly purposive and the autonomous and free has become smaller. The inadequacy of purely functional forms has come to light: something monotonous, threadbare and narrow-mindedly practical. Individual great achievements stand out from this, and for now people content themselves with ascribing them to the ingenuity of their creators, without assuring themselves of the objective aspects that authorize their achievement. On the other hand, the attempt to add imagination from the outside, as a corrective, to augment the matter with something that does not come from within it, is futile and serves the false resurrection of the decorative element criticized by the new architecture. There is nothing drearier than the moderate modernity of the German reconstruction style, whose critical analysis by a true expert would be most timely. The suspicion voiced in *Minima Moralia* that it has really become impossible to dwell has been confirmed. The form of all dwelling is burdened by the heavy shadow of inconstancy, the mass migrations that were ghoulishly anticipated by the resettlements in Hitler's reign and his war. That contradiction must be seized in its necessity by our consciousness, but without allowing it to be calmed; otherwise it will side with the disaster that still looms. The recent one, the air raids, put architecture in a position from which it could not work its way out.

The contradictory factors are two concepts that seem to be mutually exclusive: handicraft and imagination. Loos explicitly rejects the latter for the functional world: 'The imaginative forms of past centuries, the blossoming ornaments of earlier times, therefore had to be replaced by pure construction. Straight lines and right-angled edges: thus works the craftsman who has only the purpose in mind and the material and tools before him.'[12]

---

12 Loos, *Gesammelte Schriften*, p. 467.

Le Corbusier, on the other hand, approved imagination in his theoretical writings, albeit somewhat generally: 'And these [are] the architect's [responsibilities]: humanism, creative imagination, love of beauty, freedom of choice.'[13] It is safe to assume that the advanced architects usually have a tendency to emphasize handicraft, while the backwards and unimaginative ones delight in extolling the imagination. Yet one should not simply accept either the concept of handicraft or that of the imagination in the worn-out form in which they appear in debates; only then can one move beyond this binary. The word 'handicraft', something of which everyone would initially approve, covers qualitatively different things. Only amateurish ignorance and philistine idealism will resist the view that any authentic and, in the broadest sense, artistic activity demands the most thorough knowledge of the available materials and methods at the most advanced level. Only someone who has never yielded to the discipline of an artistic construct, and instead imagines its origins in an intuitionist fashion, will fear that closeness to the material and knowledge of the artist's methods would rob the artist of their original essence. Anyone who does not learn what is available and continues as before is merely bringing to light the residue of outdated formulas from the supposed depths of their inwardness. The word 'handicraft' appeals to such a simple truth, but also has a very different undertone. The first part, 'hand', idealizes the means of production in the simple commodity economy, which have been defeated by technology, degraded to a masquerade since the suggestions of the English pioneers of the 'modern style'. One associates handicraft with Hans Sachs's apron, perhaps even the great world chronicle. I sometimes cannot shake off the suspicion that such a down-to-earth archaism survives even among those younger handicrafty adepts who despise art; some only feel above art because they were denied the experience of art that cause Loos to play off art and its application against each

13 Le Corbusier, *My Work* (London: The Architectural Press, 1960).

other with such pathos. In the musical sphere, I caught an advocate of handicraft—who admittedly, with Romantic anti-Romanticism, spoke openly of a 'masons' guild mentality'—associating it with stereotypical formulas or, as he put it, practices that are meant to spare the composer's powers, and he did not insist that the specification of each task individually confronting the artist ruled out the use of such formulas. Because of people with this mentality, craftsmanship becomes what it opposes: the same dead, object-like repetition that was practised with ornaments. I will refrain from deciding whether an element of the same demon is at work in the concept of design as something isolated, something independent of the immanent demand and laws of what is being designed. At any rate, the retrospective love towards the craftsman, who is doomed to social extinction, is perfectly compatible with the distastefully boastful manner of his successor: the expert who, as unpolished as his tables and chairs and proud of his expertise, exempts himself from the very reflection required by the matter in a time that no longer possesses anything it can cling to. As indispensable as the expert may be, and as little as a state prior to labour division can be re-established in the methods of the practical sphere, a state irrevocably liquidated by society, the expert type is by no means the measure of all things. Their disillusioned modernity, which believes it has abandoned all ideologies, is a suitable mask for petty bourgeois routine; handicraft conceals handicraftiness. Good handicraft means that the means are appropriate for the ends. Ends are certainly not independent of such aptness; means have a logic of their own that points beyond them. Yet if the aptness of the means becomes an end in itself, if it is fetishized, then the craftsmanly mindset achieves the opposite of what was meant by those who mobilized it against velvet jackets and berets. It inhibits the objective reason of productive forces rather than developing them freely. Whenever handicraft is set up as the norm today, one should examine what is meant very

closely. The concept of handicraft as such exists in a functional context, and its functions are by no means always illuminated and advanced.

The concept of imagination, however, should no more be the ultimate aim than that of handicraft. The psychological truism that it is nothing but the envisagement of something not yet existent is insufficient to describe its self-definition in artistic processes—and, I would surmise, also in purpose-bound art. Walter Benjamin once defined imagination as the ability to interpolate at the smallest level. This undoubtedly goes further than the common views, which tend to glorify the concept fancifully or damn it soberly. Imagination in the production of artistic work is not a pleasure in non-committally adding spontaneous inventions, a *creatio ex nihilo*. This does not exist in any art, not even the autonomous art that Loos believed capable of this. Any penetrating analysis of autonomous art works leads to the insight that the invention added by the artist, the element that goes beyond the state of the materials and forms, is infinitely small, a marginal value. On the other hand, it would directly oppose the concept of imagination to restrict it to an anticipatory alignment with materials or purposes; then it would remain in the realm of the ever-same. It is impossible to describe Corbusier's mighty feats of imagination with the connections between architecture and the human body to which he referred literarily. In spite of everything, there is evidently something in the materials and forms the artist receives and with which they work, however little meaning they have at that stage, that is more than material and form. Imagination means innervating this 'more'. This is not as outlandish as it sounds; the forms and even the materials are by no means the natural givens the unthinking artist readily supposes them to be. History is stored in them and spirit through them. What remains of this is not a positive law, but becomes within them a sharply defined figure of the problem. Artistic imagination awakens what is stored up by becoming aware of the problem.

Its steps, ever minimal, respond to the wordless question directed at it by the materials and forms in the mute language of things. Here the separate aspects, including the purpose and immanent formal law, converge. There is an interplay between the purposes, the space and the material; none of them is a primordial phenomenon to which the whole could be reduced. The philosophical insight that no idea leads to the absolute origin, that this is itself a product of abstraction, extends to aesthetics. Thus any music that focused on the single note as the purportedly primary element has, in the meantime, had to learn that it is nothing of the kind. Only in the functional contexts of the work does it fill itself with meaning; without them, it would merely be a physical manifestation. Only superstition can hope to squeeze a latent aesthetic structure out of it. When one speaks of a sense of space in architecture, which is logical enough, one does not mean an abstract in-itself, a sense of space as such, which cannot after all be imagined except via spatial things. The sense of space is intertwined with the purposes; where it proves itself in architecture as something that exceeds purposiveness, it is at once immanent in the purposes. Whether such a synthesis succeeds is probably a central criterion for great architecture, which asks: how—in what forms and material—can a particular purpose become space? All elements are mutually related. Architectural imagination would then be the capacity to articulate the space through the purposes, to let them become a space; establishing forms based on purposes. Conversely, space and the sense thereof can only be more than impoverished purposiveness if imagination embeds itself in purposiveness. It exceeds the immanent context of purpose to which it owes its existence.

I am aware of how easily concepts like sense of space can descend into the glib and ultimately arty-crafty, and I feel the limitation of the non-expert who is not able to formulate such principles, which raise their head so powerfully in major modern architectures,

with adequate precision. Yet I might be allowed to speculate that the sense of space, unlike the abstract notion of space, must correspond in the visual domain to what is termed music in the acoustic domain. Musicality cannot be reduced to an abstract notion of time, such as the ability—helpful as it may be—to imagine the temporal units of the metronome precisely without it ticking. Similarly, sense of space is by no means limited to spatial imagination, though this latter would be indispensable for the architect, who must read their ground plans and front views just as a musician reads scores. Sense of space seems to demand more, however: that one should draw some idea from the space, not something arbitrary *in* the space that would be indifferent to it. Analogously, the musician must invent their melodies, and meanwhile entire musical structures, from time and the need to organize it. Mere temporal relations that are indifferent to the concrete musical events are insufficient for this, as is the invention of individual musical events or complexes whose temporal structure and relations to one another are not taken into consideration. In the productive sense of space, the purpose will largely take on the function of content in relation to the formal constituents the architect draws from the space; it is through the purpose that the tension of form and content, without which nothing artistic exists, conveys itself, especially in purpose-bound art. If there is any truth in neo-objective asceticism, it is that immediate subjective expression is inadequate for architecture; attempts to attain it result not in architecture but film sets—sometimes even good ones, as in the old film of *The Golem*. In architecture, subjective expression is replaced by the function for the subject. The more intensely architecture mediates the two extremes—formal construction and function—through each other, the higher its level.

The function for the subject is not a function for a universal human being defined once and for all by their physis, however; it aims at the concrete members of society. Contrary to the repressed

instincts of the empirical subjects, which in current society still crave a cosy spot and all manner of stuffiness, functional architecture represents the intelligible character, a human potential that is grasped by the most advanced consciousness, but suffocated among those people who are kept powerless to their core. Humane architecture treats humans as better than they are; it treats them as they could be, based on the state of their own productive forces as embodied in the technical. Architecture contradicts the needs of the here and now as soon as it serves need without perpetuating ideology; it is still, as the title of Loos's book lamented almost seventy years ago, spoken into the void. That the great architects from Loos to Le Corbusier and Scharoun were only able to realize a fraction of their work in stone and concrete is not only due to the incomprehension of builders and administrative committees, though this factor should never be underestimated. It is conditioned by a social antagonism over which even the strongest architecture has no power: the same society that developed human productive forces to an unimaginable level binds them to the relations of production, and deforms the people, who are in reality the productive forces, according to those relations. This fundamental contradiction appears in architecture, and it is no more capable of doing away with it than are the consumers. Not everything is right about it, just as not everything is wrong about humans, who are already wronged through the fact that their conscious and unconscious minds remain trapped in an immaturity that prevents them from identifying with their own cause. Because architecture is not exclusively autonomous, but at once purpose-bound, it cannot simply negate humans as they are, even though, being autonomous, it must also do so. If it passed over humans as they are, it would be adapting itself to a questionable anthropology, possibly ontology; it is no coincidence that Le Corbusier conceived models of humans. The living people, even the most backward and convention-bound, have a right to the fulfilment

of their needs, however false. If the idea of a true, objective need ruthlessly overrides the subjective one, it turns into brutal oppression, just as *volonté générale* has always overridden *volonté de tous*. Even in the false needs of the living, an element of freedom stirs: what economic theory formerly termed the use value, as opposed to the abstract exchange value. They consider legitimate architecture necessary as their enemy, because it denies them what they, being as they are, want and even need.

This antinomy may, beyond the phenomenon of *cultural lag*, be a result of movement in the concept of art. In order to become fully art, art must crystallize autonomously according to its own formal law. This is what constitutes its truth content; otherwise it would be subordinate to what it denies through its mere existence. As something fashioned by humans, however, it is not entirely remote from this; what it resists is contained constitutively within it. When art completely eradicates its memory of being-for-another, it becomes a fetish, that self-made and thus already absolute phenomenon, as which art nouveau dreamt of its beauty. At the same time, art is forced to undertake the effort of pure being-in-itself if it is to avoid falling prey to something that has been exposed as questionable. A quid pro quo follows from this. Anything that—as a virtual human subject— aims for a liberated, emancipated human type that would only be possible in a transformed society appears, in our current society, like an adaptation to technology as an end in itself, like the apotheosis of reification, whose irreconcilable opposite is art. This is not mere semblance, however: the more consistently, according to its own formal law, art—both the autonomous and so-called applied type— rejects its own magical and mythical origins, the more dangerously it approaches such an adaptation, which it has no world formula to resist. Thorstein Veblen's aporia repeats itself: he demanded before 1900 that people, in order to shake off the grand delusion of their pictorial world, should think in purely technological, causal-mechanical

terms. He thus approved the material categories of the same economic system at which his entire critique was directed. In a state of freedom, people would not take their cues from technology, which is there for them; rather, technology would take its cues from them. In the current time, however, people have entered technology and been left behind like husks, as if they had bequeathed their better part to it. Their own consciousness is reified in the face of technology, and should therefore be criticized from the technical, material perspective. The plausible statement that technology is there for people has itself become part of the crude ideology of backwardness; this is evident from the fact that one need only parrot it in order to be rewarded with enthusiastic agreement on all sides. If the overall state is wrong, nothing can resolve the contradiction. A utopia devised freely outside of all contexts of purpose within the existent would be powerless, since it is forced to draw its elements and structure from the existent—an uncommitted ornament. Anything that applies a ban to the utopian element, however, as with the ban on images, becomes directly subject to the ban of the existent.

The question of functionalism is that of subordination to utility. The useless has undoubtedly been eroded; the process of development has brought its immanent aesthetic inadequacy to light. The merely useful, on the other hand, is interwoven with the context of guilt, a means of making the world bleak and dismal, yet without people being able of their own accord to find any consolation that does not deceive them. If the contradiction cannot be done away with, it would at least be a tiny step to understand it. Utility has its own dialectic in bourgeois society. Utility would be something of the highest value, the thing-become-human, a reconciliation with objects that no longer shut themselves off from humans, and on which humans no longer inflict shame. The perception of technical things in childhood, when they appear as images of something close and helpful, unsullied by profit interests, promises such a state; its

conception was not unknown in social utopias. A conceivable vanishing point for development would be for the things that have become fully useful to lose their coldness. It would then not only be humans who would cease to suffer because of the object character of the world; the objects would also benefit as soon as they found their purpose, rescued from their own thingliness. Yet, in society, everything useful is distorted and bewitched. The impression it creates, namely that objects are there for the sake of people, is the lie; they are produced for profit and only satisfy needs as a secondary function, arousing said needs according to profit interests and adapting them to these. Because that which is useful, that which benefits people and is cleansed of all domination or exploitation, would be right, nothing is more aesthetically unbearable than its current state, in which it is enslaved and deformed to its core by it. The raison d'être of all autonomous art since the early bourgeois period is that only the useless can stand in for what would one day constitute utility, successful use and contact with objects beyond the opposition of use and uselessness. This causes people who want something better to revolt against the practical. If they proclaim it reactively and dominantly, they join their mortal enemy. There is no dishonour in work, as the saying goes. Like most sayings, this only shouts down the opposite truth: exchange dishonours useful work itself, and its curse extends to autonomous art. In the latter, the useless—fixed in its limited and particular form—is helplessly exposed to the critique to which the useful subjects it, while in the useful, that which is simply the case shuts out its possibilities. The dark secret of art is the fetish character of commodities. Functionalism seeks to break out of its entanglement, tearing vainly at its shackles as long as it remains obedient to an entangled society.

I have tried to draw your attention to contradictions that cannot be resolved by a non-expert; it is doubtful whether they can currently

be resolved at all. In that sense, I must reckon with the possibility that even you will accuse me of uselessness. In my defence, I would say that the concepts of 'useful' and 'useless' must not be accepted uncritically. The days have passed when one could isolate oneself and focus purely on one's own task. If an idea is hastily challenged to explain its actual utility, this tends to bring it to a halt at the very point where it leads to insights that might one day unexpectedly contribute to better practices. An idea is subject to a compelling driving force no different from what you are familiar with from working on your own material. The crisis which manifests itself in the fact that the artist's concrete work, whether tied to purposes or not, can no longer be naive—that is, it can no longer follow a predetermined path—requires the expert, however proud of their handicraft, to look beyond it in order to do justice to it. This applies in a twofold sense; firstly, in terms of social theory: they must take into account the location of their work within society, as well as the social barriers they encounter everywhere. This becomes a drastic matter in relation to the problem of urban planning, where architectural and social questions such as the existence of non-existence of an overall social subject collide, and by no means only in matters of reconstruction. It goes without saying that urban planning is inadequate if it is based on particular purposes, rather than those of society as a whole. The immediate practical aspects of urban planning do not coincide with those of a truly rational form thereof that is free of social irrationalities: what is missing is the overall social subject that should be the target of urban planning; it is not least because of this that it risks either descending into chaos or inhibiting individual productive architectural achievements.

On the other hand, and I would like to say this to you with a certain emphasis, architecture, and indeed all purpose-bound art, calls once again for the much-maligned *aesthetic* reflection. I know how suspicious the word 'aesthetics' sounds to you; no doubt it evokes

professors gazing skywards and concocting formalistic laws of eternal, imperishable beauty that are usually no more than recipes for fashioning ephemeral classicist kitsch. It is time for the opposite in aesthetics: it must absorb the objections that it thoroughly spoilt for all true artists. If it continues academically without the most unflinching self-criticism, it will already be doomed. Yet just as aesthetics, as an integral part of philosophy, waits to be moved further by thinking efforts, recent artistic practice requires aesthetics. If it is the case that concepts such as what is useful or useless in art, the separation of autonomous and purpose-bound art, imagination and the ornament are once again up for discussion before one classifies what one means as affirming or rejecting such categories, aesthetics becomes a practical need. Beyond the most immediate tasks, the deliberations you are forced daily to undertake are aesthetic ones, like it or not; you are in the same position as Molière's Monsieur Jourdain, who, to his astonishment, learns in rhetoric lessons that he has been speaking in prose for his entire life. If what you do forces you into aesthetic reflections, however, you submit to their gravitation. They cannot, out of sheer specialist purism, be broken off and summoned again at will. Whoever does not energetically pursue the aesthetic idea tends to fall back on amateurish auxiliary theories and clumsy attempts at self-justification. In the field of music, one of the most technically competent composers of the present day, Pierre Boulez, who took constructivism to extremes in some of his works, emphatically voiced the demand for aesthetics. Such an aesthetics would never presume to trumpet principles for what is beautiful, nor accordingly what is ugly; such caution would already show the problem of the ornament in a new light. Today, beauty has no other criterion than the depth with which the works grapple with the contradictions that furrow them, and which they only overcome by following, not concealing them. Merely formal beauty, whatever that might be, would be empty and void; beauty of content would be lost

in the pre-artistically sensual enjoyment of the beholder. Beauty exists either as the result of a parallelogram of forces or not at all. A different aesthetics, whose programme would take on clearer outlines the more urgently its need were felt, would—unlike traditional aesthetics—no longer view the concept of art as its self-evident correlate. In thinking art, aesthetic thought today must go beyond it, and thus also beyond the hardened opposition between the purposive and the purpose-free, which afflicts the producer as much as the beholder.

# Luccan Memorial

*For Z.*

Everyone says that life in the south takes place in the street, but that is only half the story. Equally, the street becomes the domestic interior; not only because of its narrowness, which turns it into a corridor, but most of all because there are no pavements. The street itself does not even resemble a roadway when cars squirm though it. They are driven like carriages, not automobiles, as if the drivers were keeping a tight rein on them and dodging pedestrians by centimetres. To the extent that life is still what Hegel called substantial, it absorbs technology too, so it is not because of the latter. The narrowness is that of the bazaar, and hence phantasmagoric: living under the open sky, as in the cabins of rowing boats or in gypsy caravans. The separation between the open and the roofed is forgotten, as if life were remembering its distant nomadic past. The displays in shop windows, even the most meagre, have something of treasures; one need only walk past them to own them. Their allure is itself the happiness it promises.

Even with the ugliest Italian girls, of which there is no shortage, one can hardly imagine them being what is now prosaically called 'uptight', fending off non-existent attacks on an equally non-existent virtue. In northern regions, if a girl's skirt slides up too much, she might zealously pull it down and voice her unwillingness, even if

there is no one willing. The same gesture from an Italian girl means that etiquette, *decoro*, demands it. By carrying out a ritual without claiming it as her own feeling, however, she becomes as strongly identified with the gesture as with a humane convention. It allows the possibility of deviating or conforming. We learn from it that coquetry is a behaviour of an accomplished culture. If a shop girl goes home hastily and alone after work, however, it has something of the adventure of the unaccompanied lady.

In Italy, aspects of the patriarchal order, the subordination of women to the male will, have survived the emancipation of women, which was as unstoppable there as elsewhere. This must be exceedingly pleasant for the men; it probably causes much suffering to the women. Perhaps that is why some girls have such deadly serious faces.

Faces that look as if they were made for great, possibly tragic destinies, but which are probably simply rudiments left over from the times when there really was such a thing, assuming there ever actually was.

Today, for all its great past, Lucca is provincial in terms of its national significance, as are most of the shops and clothes. It is probably deluded to imagine that the consciousness of the residents were any less so. But they do not seem so. The tradition of their people and their particular area pervades their appearance and gestures so thoroughly that they have been shaped and removed from that barbarism of the provinces from which, in northern climes, even the most beautiful medieval cities do not protect their dwellers. The provinces are not all alike.

After asking around endlessly I reached the Palazzo Guinigi, in a quarter I did not yet know. Venerably Tuscan and half-decrepit, the plaster broken off in a manner reminiscent of the palaces in the centre of Vienna. On the very high tower a holly oak, the city's landmark, though no rarity in Tuscany. The ground floor was filled with bicycles and all manner of junk. I found my way through it to the edge of a garden of unkempt splendour; it supplied what the grey of the forecourt withheld. Above the bushes a radiant palm, in the background the windowless, yet not bare side wall of one of the medieval palaces that form the entire street.

In Italian situations, there are often unplanned and seemingly inexplicable gatherings of people who are simultaneously sharing in something desired, possibly joining in. At times, it is difficult to shake off the corona. On the other hand, some people are helpful and friendly without any ulterior motives. Without a swaggering jack-of-all-trades who was not overly concerned about the truth and offered confessions that no one wanted to hear, I would never have visited the Botanical Garden, the Villa Bottoni or the ruin of a classical theatre at the edge of the villa grounds. The embarrassing is inextricably intertwined with the things for which one is grateful.

On the autobus to Pistoia. Even the pains taken by the motorway to avoid anything that is not prosaic or an advertisement cannot fully succeed in concealing the beauty of the Tuscan landscape. Such is its magnificence that it even wins out over the practice of desolation.

An alleyway of deepest poverty in Pistoia: Via dell'abbundanza. Similarly, I once saw a sign in Whitechapel bearing the words 'High Life Bar'.

Regarding the physiognomy of Tuscan towns: sometimes mighty cathedral squares with imposing architecture appear suddenly, abruptly, in the web of roads; even the gloomiest ones lead there. The splendour that descends upon squalor manifests, before all symbolism, the wonder and grace those symbols teach.

The entire city of Lucca is enclosed by a wall. Just as in German cities, gardens were later planted there, but it was left untouched, unsmoothed. It is covered densely with plane trees. They form avenues of the kind normally associated with poplars—dark, somewhat like dreams painted by Henri Rousseau. The aeroplanes that regularly perform their cavalcades around ten in the morning do not fit badly into the picture. In many places along the great stone wall, little mounds rise from the earth. On summer-warm autumn days, one can see vagrants sleeping peacefully there. A comforting thought: if there were no more poverty, humanity would have to be able to sleep as unguardedly as only its poorest do today.

Imagine that God knows how many millions emigrate from this country to Canada, the states or Argentina, when the opposite should be the case. Incessantly, as if it were a ritual, the expulsion from paradise repeats itself; they must eat their bread in the sweat of their brow. In the face of this, all theoretical social critique becomes superfluous.

Looking at Pisan-Luccan architecture as an art-historical layman, I am struck, despite many counterexamples, by a discrepancy between the expansive facades, with their wealth of forms, decoratively unleashed a full five hundred years before the Baroque, and the interiors, with their simple basilica ceilings. Historically, this may be explained by their age; the churches were consistently erected in the squares of their pre-Romanesque precursors, and appear to have

preserved something of their structure. But the musician in me is reminded of the primacy of the melody in the upper voice over the other dimensions in so many Italian compositions: homophonic architecture. Where there is construction in works of art, the aspect of control over nature is especially strong, reinforced by the resistance offered by nature. If the latter is warm and lush, the need for construction is likely to remain weaker. The oft-cited sense of form among Latin peoples indeed seems a-constructive, relaxed; hence the easier transition to convention, as well as the fact that this convention is more casual than in the north.

A discovery, even if others have made it before: a relief at the baptismal font of the Basilica of San Frediano that presents itself both full face and in profile at once, dominated by a large, angular eye, and geometrical too; its stylization, which removes any similarity with the living, lends it an enchantingly ancient expression. It is undeniably reminiscent of late Picasso, though he is scarcely likely to know this extravagant sculpture. The substantial quality of Latin life feeds a subterranean tradition up to the point where tradition is discarded.

Outside the San Michele bar, opposite the famous church. Deep, cold twilight. Defenceless, as if it might collapse at any moment, the empty four-storey facade extended into the greyish-blue sky. I suddenly understood why, devoid of function and contrary to architectural wisdom, it is so beautiful. It displays its own functionlessness, not claiming for a moment to be anything other than the ornament that it is. It is no longer naked semblance: it is absolved.

# The Misused Baroque

*For Nicolas Nabokov*

'Baroque' is a term of prestige. The name served as a gate through which the culture industry entered culture at least as far back as *Der Rosenkavalier*. Already in 1925, Karl Kraus published an essay in *Die Fackel*, 'From the Baroque Period', in which he took the memoirs of a diplomat's wife as a starting point for a denunciation of the sphere in which the word is overused, and which has now fully embraced film. 'The people one now sees in Salzburg in the summer, with their Baroque decoration, scarlet heralds, "gold-shimmering fanfares", church bells, organs and noisy vibrations, so thoroughly defy description that no description can defy them any longer.'[1] The catchword for a period in art history originally defined in precise fashion by Wölfflin and Riegl has, since the time of their publications, assumed a largely ideological function. Those who rave about the Baroque today do so to prove that they belong to culture, indeed belong at all. Their enthusiasm is very often that of a neutralized consciousness that is not overly selective about the objects of its enthusiasm. This is clearest in music; the term 'Baroque' was transferred to it later on, first by Curt Sachs and then, most influentially, by Friedrich Blume. Blume advises against an overly narrow definition of the musical Baroque; his rich knowledge of the material taught him what heterogeneous elements are subsumed under that

---

1 *Die Fackel* 27(697–705) (October 1925): 86.

musical classification. If one follows his reasoning, almost all that is left of the purported unity is the general principle of contrast. He defends the nomenclature nonetheless, not hesitating to assert that in the Baroque, writing and music—like the technique for depicting nakedness in painting—developed 'a glittering language of sensual responsiveness and bittersweet suppleness',[2] even though this contradicts both the role played by the notion of Baroque music among its current devotees and the nature of the music itself. This music was not Tristan, Salome or Debussy, and its overall habitus was not one of varied nuances; it owes its recent, oppressive popularity more to its block-like simplicity. Insisting on the identity of the Baroque spirit in the acoustic and visual domain passes all too quickly over the irreconcilability of the concrete artistic manifestation in the here and now. Yet the music of that time could scarcely have been resurrected if the understanding of the Baroque had not cast on Tunder, Buxtehude, Schein, Biber and countless others some of the reflected glory of the architecture of Fischer von Erlach and Balthasar Neumann. The universal use of the name is only possible as a result of the aspecificity and vagueness of the diluted contemporary consciousness of the Baroque.

This consciousness goes well with the culture by which it swears. A person can comfortably declare themselves a disciple of Baroque music without distinguishing particularly between the individual authors and works in its repertoire. In fact, in the breadth of that body of work, they are fatally similar to one another through their aspecificity—or, academically put, the retreat of personal style. Musically, there is little occasion for what is most important, namely the perception of qualities, something that art history still demonstrates in its treatment of the Baroque. Possibly the deficiencies of

---

2 Friedrich Blume, *Syntagma musicologicum* (Marin Ruhnke ed.) (Kassel, Basel and London: Bärenreiter, 1963), p. 73.

the object are even considered a virtue, as proof of a supra-personal style, not yet fragmented by the subjectivist fall from grace; at the same time, the idea of the Baroque is celebrated tirelessly as the emancipation of subjectivity from the enclosure of the Renaissance. The modish fascination with boredom is presumably mediated by some standardized epiphany, such as the childlike joy at recognizing the ever-same. When a harpsichord or clavichord chirrups on the radio and the instruments accompany it with their diligently repetitive motifs, the illuminated sign saying *Baroque music* flashes brightly, like *religion* with organ sounds or *jazz* for squawking syncopations. With the Baroque, this form of reaction corresponds to what Jürgen Habermas has called the ideology of the declining middle class. Those who declare, with eyebrows raised, their allegiance to music with figured bass, possibly in opposition to the nineteenth century and Romanticism, are posing as discriminating and strict in their taste without having to prove that they are capable of making objective distinctions. The neutralization has gone so far that one lady who could be termed a Baroque fan found such music especially erotic, whereas the spokespersons of the Baroque revival justify it ascetically, with a veritable aversion towards any expressive-erotic character. It bothers no one that in music, the meaning of the word 'Baroque'—which, as we know, refers to the 'crookedly round', to the invasion of the utmost symmetry by the asymmetrical—has no significance whatsoever. If one inevitably goes beyond the characteristics that apply to a basic visual form, and are not even especially apt there, one arrives at what Riegl, like others, calls 'peculiar, unfamiliar, extraordinary'.[3] This important art historian immediately realizes the inadequacy of this generalized definition: 'The extraordinary is also the goal of all classical, Roman and Renaissance art'.[4] Art stands out from

3 Alois Riegl, *The Origins of Baroque Art in Rome* (Andrew Hopkins and Arnold Witte trans and eds) (Los Angeles: Getty, 2010), p. 94.

4 Riegl, *The Origins of Baroque Art in Rome*, p. 94.

the grey of normal bourgeois self-preservation through its mere existence; the non-normal is its a priori, its own norm. Riegl concretizes the idea of the extraordinary in the Baroque through the idea of the internally contradictory, one could even say dialectical. But the music that leeches off the fame of the Baroque keeps from the outset to the ordinary, not the extraordinary; it radiates anti-sex appeal.

To be sure, the connections between visual art and music between the late sixteenth century and around 1740 are generally undeniable. Parallels such as the inclination towards pomp or forms based on stark contrast rather than transition are obvious. And anyone who is aware of the asynchronicity of art forms, especially the consistently belated nature of music, will at least expect as much unity as can be found in the constitutive traits, the historical aporiae, of the periods themselves. The similarity between the technique of using several levels set apart from one another in terms of their depth, which Riegl traces as far back as Michelangelo, and so-called terraced dynamics, indeed the general approach of layering individually uniform, directly contrasting complexes in Baroque concerti, seems plausible at first glance. But only at first glance. The analogies have a way of evaporating as soon as one pursues them; Baroque painting already knew the technique of transition as much as that of contrast, as well as atmospheric intertwinement and the dissolution of definite contours, the *sfumato*. There is nothing of this in the music of the same time. Generalized talk of the Baroque is ideology in the precise sense of false consciousness, a violent simplification of the phenomena whose propaganda it supplies.

The authority of the Baroque is above all the authority of the idea of style. The Baroque was the last powerful and exemplary style recorded in art history; the Rococo, whose musical equivalent would be the galant style, is dragged along as an appendix, while the Empire and Biedermeier styles, compared to the collective force of the Baroque, are either fictitious or withdraw resignedly to the confines

of the private. It is not a disparagement of the authentic Baroque works or the stylistic idea they embody if one equates the cult of the Baroque with that of style, for the cult emerged with the thesis that the power of stylistic formation had been extinguished. This extinguishing was a reaction to the syncretism of the Wilhelmine and Franz Joseph periods. Yet style alone is no guarantee of aesthetic quality, though its preponderance sometimes makes it difficult to recognize the latter. An impartial observer need only have seen how many inferior Baroque buildings there are in southern Germany, Austria or Italy, how many massive allegorical paintings churned out in the routine of artists' workshops, often signed with big names, are clogging up museums, to realize how little style alone is worth. It only gained its nimbus when it dwindled, rightly and through its own fault. The force of style, probably already in High Gothic architecture, was at once a form of violence; it did not merely burst forth spontaneously from the zeitgeist, but was also dictated and organized. The restorers of medieval churches who are confronted at every turn with the depredations of the wave of Baroquification would have a thing or two to report about this. To the extent that the Baroque coincided with the Counter-Reformation, one sees an unmistakable will that was not an artistic one: the masses who had abandoned the church were meant to be impressed and brought back to the fold. The surplus of effect without cause, which was highlighted in critiques of the Baroque when people still dared to judge it, came from this will; when it dominates, the immanent quality becomes questionable. In this sense, the wave of Baroquification, for all the differences in quality, is embarrassingly similar to what, with the imprint of the culture industry and surely few stylistic ambitions, might today be termed neonization: the seemingly irresistible need to emulate a vaguely sensed model of American up-to-dateness without regard for the demands of form and structure, such as modernizing every restaurant in ways that serve neither aesthetic logic

nor the comfort of the guests concerned, but only the worry that something might interfere with the sounds of the jukebox or the taste of Coca-Cola, and even encourage the guests to linger and engage in conversation. The verdict on style will have to be revised in the light of the style—or rather anti-style—breaking out today, whose unity is dictated by its monopoly, not by the worldview it wrongfully extols. Radical aesthetic evil is no longer embodied by the absence of style, but rather by ominous unity. This also has a retroactive effect on those periods in which style had not yet become a parody of itself. Style as ideology, whose widespread formula is the Baroque, stands in strict counterpoise to the current situation. The latter demands the utmost nominalism in art: the primacy of the individual, internally coherent and structured artistic product over any general, abstract instructions, any prescribed canon of forms. Following the aesthetic subject's critique of the objectivity of any form that had not passed through it, such form is no more than a repressive menace. The glorification of the Baroque as a style responds to an urge that lags behind social and intra-aesthetic developments in much the same way that social developments themselves hasten such regression.

Severed from the truth content of style, today's Baroque ideology effortlessly aligns itself with something self-contradictory. The clichéd overextension of the concept allows people to foist on it a longed-for meaningful and divinely vaulted state of the world on the one hand, and on the other hand a boldness of subjective emancipation and urge towards the infinite in which they flatter themselves that they, along with inescapable traits of modernity, are reflected. This dual function says more about the current time than about the Baroque; it mirrors the growing heteronomy of consciousness. The subjects cannot enjoy their formal freedom, which corresponds neither to material freedom nor their own constitution. They whimper desperately for the bonds irreversibly broken by bourgeois

society. Nonetheless, they cannot evade their own late-bourgeois consciousness, for which such bonds are no longer substantial and which, to the extent that it has any productive power, pushes beyond what is intellectually prescribed, beyond the ontology of any one guise. The mollusc-like concept of the Baroque, especially its application to music, can be applied to the contradictory at will, from the supposedly extravagant imagination and the almost surrealist shocks of Piranesi's imaginary dungeons to the unwavering stamping of figured bass pieces, whose stubborn progressions can be countered with as much gusto as the downbeat in jazz; it is no coincidence that so-called pre-Classical music in particular is jazzed up so often.

Undoubtedly there are authentic correspondences in the history of the spirit. When El Greco was popular during expressionism, there was a sense of elective affinity with an anti-naturalist impulse that had scarcely been fully absorbed in painting. The recent interest in mannerism is entirely different; it should rather be understood together with the helplessness of academically established intellectual history to deal with newer phenomena. Despite certain similarities to mannerism, a way of thinking that denigrates whatever is alienating in the new art and resists simplistic classification, yet simultaneously accommodates it through historical reminiscences, lacks validity. The specific understanding of what is happening today will have to seek its point of attack in the difference of import in the two cases, and also to derive the differences between the phenomena themselves from this. In the art of disparate periods, elements that are sensually similar can have entirely opposing meanings. The foundational layer of modernity is reached by the gaze that penetrates most deeply into its temporal specificity, not by a generalized adaptation to a blanket concept that covers different periods at the expense of their particularity. But when, as recently in the case of some aged, once-modern painters, the Baroque is presented—whether in lectures by artists or by commentators—as artistically

ambitious, this is pseudomorphosis rather than correspondence. One of Alois Riegl's significant achievements was that, already in Michelangelo, he showed that the principles of the Baroque were 'structive', that is, he identified them in the construction. The fact that the Baroque, whose tendency towards the decorative in all areas is repeatedly and monotonously asserted, is nonetheless a style, more than mere finery in spite of all the wasted plaster, is based on those structive elements. It is hardly a mistaken hypothesis that the surviving works of the visual Baroque in all areas are those whose sensual effects follow most necessarily from the construction, and are mostly deeply reconciled with it. There is nothing of this in the Baroque gestures of modern painters; fleeing from the issues of construction that have been irresistibly advancing since Cézanne, they become absolute for themselves. Because the mere gesture, without any subcutaneous skeleton, is no longer enough, they borrow educated elements from the Baroque. Such painting is decorative painting, even if it was not commissioned directly for festivals, with all the insignias of the secondary and derivative, which decorative painting evidently cannot shed as long as it measures itself by its context of effect, which is in turn impossible to ignore in stage works. Neo-Baroque is no better than the neo-Gothic style of the nineteenth century. The mixture of modern dissolution and historically venerable élan that has had so much resonance for the representational audience since the Second World War, as well as that of the Reinhardt era,[5] is fragile to its core, corroded by the same arts-and-crafts aesthetic that, in harmless impotence, was content with obvious stylistic pastiche only 50 years ago. Meanwhile, the candlelight used back then to illuminate picturesquely draped female harpsichordists as they created the right mood in castle settings has entered the paintings of great old men, whose greatness is lost as a result. Their practices converge with the

---

5 Max Reinhardt (1873–1943) was an Austrian theatre director and producer who founded the Salzburg Festival in 1920. [Trans.]

culture industry, which has a tendency towards totality in any case, violating and swallowing what it considers cultural artefacts in order to exploit them. The site of this absorption process is the cultural landscape. Areas without factories, especially those characterized by reasonably unshaken Catholicism, take on a monopolistic character through their scarcity and themselves become luxury goods, a complement to the industrialism in whose midst they flourish. Their Baroque has become a poster of total culture for tourist purposes, and this damages its own beauty. This beauty could only be restored if the commercialization of the uncommercial were deprived of its social and economic basis. It is surely not so far-fetched to suppose that the Baroque ideology should also be viewed with suspicion in political terms. A musician who embarked on avant-garde adventures, but then became fearful of his own courage and broke his promises, justified this by saying that he was too deeply rooted in the South German Baroque. His reaction is akin to the mentality which, not so long before then, had raged against what it denounced as rootless.

Of course, this rooted man was talking about music, where the Baroque concept augments visual art with its opposite. The ideal is not that of sensual culture, not culinary, but rather failing. The Baroque could never have become an ideology for such disparate things if the very use of the term did not already contain objective untruth. G. F. Hartlaub, the former director of the Mannheim Kunsthalle, was the first to highlight this expressly in his far too little-known book *Fragen an die Kunst* [Questions for art]. It is all the more persuasive because it concedes the elements of truth in a broad concept of the Baroque in order to make the decisive difference vividly clear. The text, whose title places a question mark behind the phrase 'Baroque music'—a phrase Riemann had already distrusted—can be encapsulated in a thesis that the author himself, with the utmost modesty, formulates as a question: 'In musical art, is not

anything that refers to the Baroque elements in the visual arts of its time actually located at an "archaeo-Baroque" level?'[6] The core of Hartlaub's argumentation is his demonstration that Wölfflin's binary oppositions, which Sachs transfers to music, are unsuited to it; this has also been shown in music-historical research with reference to individual categories. Hartlaub considers it likely 'that one can only understand the music written approximately between 1570 and 1745, assuming one must apply a stylistic category to it that was taken first of all from art history, as the final grand development of a mode of expression that was still archaic overall.'[7] Hartlaub makes it clear what the controversy is about by means of a model: 'Anyone familiar with the paintings of Salvator Rosa would, without any prior historical knowledge, initially expect an entirely different sort of music from him as a madrigal composer! The stylistic discrepancy between the work of the musician and that of the painter seems incredible; one almost doubts that they had the same artistic creator.'[8]

One could go a step further with a comparison between the imago of music in Shakespeare—as in the final act of *The Merchant of Venice*—and the comparatively very primitive pieces of the Elizabethan virginalists. Citing Bach's immense output as a counter-example would not do any good; even in the view of those who advocate the Baroque concept in music as eloquently as Blume, Bach cannot be encompassed by this category. This is enough to overturn the primacy of the concept of style itself: for what use is it if the greatest exponents of an art form prove incommensurable with the style of their period? Style would then be reserved for mediocrity, and sometimes one cannot help but feel that those who treat it as an aesthetic skeleton key are sympathetic to mediocrity. It is all too easy

---

6 Gustav Friedrich Hartlaub, *Fragen an die Kunst* (Stuttgart: K. F. Koehler, 1950), p. 165.

7 Hartlaub, *Fragen an die Kunst*, p. 169.

8 Hartlaub, *Fragen an die Kunst*, pp. 168ff.

to present church choirs and local painting schools, with efforts at collectivist mediation, as more objective than great art, as if there were an artistic objectivity realized other than through the powerful escape of the subject. Hartlaub is right to speak of his disappointment with the old affect-based music,

> for all its chromaticism, its dissonant suspensions and bold modulations, which after all, in comparison to post-Classical and Romantic works, remained mere seeds or buds—in stark contrast to the extreme methods of the painters and sculptors! There is at least one pole of the Baroque in the visual arts where one finds the secret, self-destructive longing for total dissolution, absorption, the self-loss of all restricted form in an animated chaos of substances.[9]

But then one should avoid the term 'Baroque' for the music of the figured bass period, which was not so much abundant as disciplining. The word carries an association that was anathema at least to North German Protestantism, which shaped the current image of Baroque music.

Hartlaub attacks in the place where the expanded concept of the Baroque, lacking any convincing technical criteria, claims its territory: the spirit of the Baroque. He shows that for the historically impartial, living consciousness, the music of the period implies the opposite of that spirit. This divergence, which amounts to no less than the rejection of the Baroque concept for music as a whole, is explained with reference to the asynchronicity of the arts, which is in turn based on their own nature:

> The profoundly inward character that corresponds to music in the human heart was still in a state of dependence, while the more peripheral character expressed in the visual arts

---

9 Hartlaub, *Fragen an die Kunst*, p. 171.

was already demanding exaggeration and dissolution. An impulse that had to produce veritably baroque phenomena (and thus also symptoms of exhaustion) in the latter case could only bring about archaic generalizations and regulations in the former.[10]

It is true that the assertion of the 'profoundly inward character' of music, which would not exist without the urge towards sensual externalization, is as contestable as the cult of inwardness in general. According to Hartlaub's own argumentation, subjectification is a historical product, certainly no invariant. At the same time, the knowledge of music's belated character, which once fed Busoni's trust in its youthfulness, retains its strength. The dialectic between the arts and art pervades history; it makes the individual phenomena ambivalent in themselves. The structural connections between music and visual art against whose abuse Hartlaub revolted undoubtedly extend further than he could see. One can challenge a statement like this one: 'Who would not feel'—in contrast to the deceptive effects in the visual realm—'that confidence-inspiring testament to authenticity and solidity of craft that characterizes the entire figured bass period—even where the schema, the formulaic quality (in the sequences, for example) becomes unmistakably clear!'[11] Decorative aspects can be uncovered down to the details of Bach's techniques, ruptures between the musical phenomenon and the motivic work actually carried out, contradicting what one might call Bach's own archaist rejection of the galant style. The triple fugue in C sharp minor in the first book of *The Well-Tempered Clavier*, a five-part piece, has a stretto that has been described as a pseudo-ten-part texture; through constant overlapping entries of the theme, it creates the illusion of a multitude of non-existent voices. This sleight of hand

---

10 Hartlaub, *Fragen an die Kunst*, p. 182.
11 Hartlaub, *Fragen an die Kunst*, p. 170.

recalls the earlier practice of small theatres in which military processions had the departing soldiers continuing behind the stage and re-entering it. In the middle of the fugal system, which is generally considered so rigorous, an illusionist principle was adopted that is comparable to the tricks of Baroque architecture and had a profound influence on Viennese Classicism. This complex might even be judged to include a procedure that became honourable after Bach, and through him in the fugue manuals, but is irreconcilable with the strict fugal method: development sections that only use fragments of the subject, usually the first part. Though they reap the effect of motivic economy, of so-called logic, they do not fully honour the duty it involves. Handel can be exempted in such matters, since his fugues abandoned this principle in favour of the pastose style, which does not tolerate any thoroughgoing articulation of the musical fabric; that did not make his fugues any better. Such observations may sound like technical hair-splitting, but have far-reaching consequences: a music of which one might believe that it need not feign anything, since it does not represent anything, nonetheless partakes of the illusory character, in what the speculation of German Idealism later termed aesthetic semblance.

This participation contains an explosive dialectic. Its medium was the inward turn of music, its subjective mediation. Music constituted itself as the language of the subject, in that it appeared to be the expression of subjective feelings that it imagined, as it were depicted and removed from reality. This principle of illusion gave rise to the development of the decorative and ornamental, which later collided with the demand for material coherence and finally forced the abrogation of the tonal idiom, which was completely infused with the principle of illusion. To grasp the element of unity in the divergent art forms, one must immerse oneself in such complexities; one must not content oneself with the facade that satisfies the concept of style and was dominant during the Baroque. The great

art historians have faced this, yet academically established musicology has hitherto failed to do so; only outsiders like Halm, Kurth or Schenker sought to gain full technical insight, which, in establishing the coherence or incoherence of the works, would simultaneously be critique. Technical analysis does not imply a description—consistently conforming to the idea of style—of consistent genre traits; not the general schemata and characteristics of the concerto grosso, the da capo aria, the fugue or even the treatment of basso continuo, but rather a micrological insight into the composed work and its specific, unexchangeable laws. It is from the particular work, and admittedly its connection to the genre through subordination, deviation and the relationship between them, that the spirit of a music, and probably any art, emerges; it does not float freely above this. It vanishes upon a reduction to genre traits. Recognizing this, however, requires an affinity for art—taking a position on the producer's side, as it were—that is lacking in science, and which science probably even disdains in honour of its own scientificity: this affinity sometimes finds an overly close knowledge of the works suspicious. Something that is still fascinating about Riegl is that he was not content simply to assert the structive nature of the Baroque, but actually showed the respective structural aspects in detail. By contrast, even as outstanding a connoisseur of the entire music of the Baroque period as Friedrich Blume dismisses such an approach, perhaps fearing that the musical concept of the Baroque might not stand up to detailed technical analysis. In a polemic against Riemann, he expressly rejects 'descriptions of a merely technical nature.'[12] According to him, the Baroque in music is a concept from the history of style, and relates to the content rather than technical issues of composition. He argues that one must move away from the categories derived from 'empirical stylistic forms', namely technical

---

12 Blume, *Syntagma musicologicum*, p. 78.

categories—he means Wölfflin's binary oppositions—towards their 'expressive value'.[13] What is magicked away is the central question, self-evidently important for the art historian, of how that content is mediated to become aesthetic appearance. Such a view, which seems to be dominant in musicology, is based on the unquestioned notion of something almost being-in-itself, or at least on the convincing definition of an elusive intellectual content compared to which technique is considered external, secondary and unworthy of music-historical examination. This is not openly declared, but can be read clearly between the lines. A lack of close contact with the matter is presented as historical far-sightedness. Technique appears under the unfriendly name of outward stylistic traits; its opposite which refers to the content, as derived from philosophy as the zeitgeist that, for its part, would need to be philosophically rethought. Blume elaborates:

> With the insight that the musical Baroque consists not in the more or less questionable congruence of outward stylistic traits with those of other arts, but rather in the inner unity of a zeitgeist, the doubt as to the simultaneity of music with said arts, which appears often in literature and can be traced back to Nietzsche, dwindles. 'Zeitgeist' is understood here not only in the sense of an effective factor that, inexplicable on its own, forces the people of a certain time and space into a shared form of thinking, feeling and utterance, but also in the sense of a particular way in which the people of a period see themselves and understand their relation to the physical and metaphysical world. True simultaneity is not proved

---

13 Blume, *Syntagma musicologicum*, p. 77. The word *Aussage* in the original term *Aussagewert* refers to a statement or message rather than the more private connotations of 'expressive'; expressing is here meant more in the sense of conveying a message. [Trans.]

by the fact that some outward stylistic traits of painting of literature can be placed in analogy to those of music.[14]

One certainly wonders how one is to move beyond what Blume too describes sceptically as a 'vague undertaking' without engaging with the concrete techniques. The refusal to do so is supported by a consensus in the ideology of education, which gives unqualified precedence to the spirit over the letter. In the section devoted to an apologia for the concept of the musical Baroque, Blume writes:

> But because every categorization of intellectual phenomena is ultimately an a posteriori abstraction from the fluctuating abundance of real life, such imprecision can probably be accepted if it helps to overcome the isolation of music in the history of its techniques and to make it comprehensible as a product of the driving intellectual forces of its period. It follows from this that the introduction of the term 'Baroque' into music history is perhaps not necessary, but it serves a purpose after the advances in art-historical and literary research filled the term with the content of particular tendencies and forces in intellectual history.[15]

It is only in their technique, however, that the driving forces of the music of a period are to be found. Paradoxically, the anti-intellectual nature of so much music history stems from the fact that it seamlessly adopts a concept of intellectual history that is as obsolete as its philosophical constitution through Wilhelm Dilthey. References to 'emotional-intellectual foundations' remains mere assurance and decoration for as long as it does not prove itself in the composed work, just as it once did for the great art historians in the painted or constructed work. Anyone who treats the intellectual import of art

---

14 Blume, *Syntagma musicologicum*, p. 76.
15 Blume, *Syntagma musicologicum*, p. 79.

with gravity, as a truth content rather than a non-binding super-structure that is meant to consecrate art's observation, and possibly avoids being drawn into analysis out of reverence, must demand that the central quality of the works be placed in transparent relation to their immanent constitution and formal laws. The philosophy of art, which is required to construct its spirit, is closer to technique than to intellectual history. The locus of the spirit in the works is their technical realization; the concept of style, which was as dubious for composers such as Schoenberg as it is to philosophy, only offers a surrogate for it.

How greatly the primacy of this concept disfigures the very thing that matters, at least in music, is shown by the way it pushes back the question of the quality of art works. It is inseparable from the question of truth content, which determines the value of important works—but only in its varyingly tense and contradictory relation to the realized form. The indifference of the humanities to aesthetic quality—Scheler would have called it world-blindness—may partly be a result of Riegl's famous category of artistic will. It can be misused in order to approve lesser works simply as expressions of a stylistic principle, without considering the question of their own coherence. Then aesthetic quality falls prey to a relativism that, already in Dilthey's work, was combined with impotently grandiloquent intellectual history. There is an unacknowledged complicity between the pedantry of an academic industry that, under the pretext of refraining from any claims that are not absolutely watertight, clings to the most external facts, aspects that have no bearing on the inner character of the works, and an irrationalism that, dressed up as silence before the creative secret, keeps out what is essential and consigns it to the realm of emotion, and hence blind wilfulness. The illusion of relativity in the quality of art works dissolves as soon as their technique, as the epitome of their coherence, is uncovered. The dominant Baroque ideology leaves little trace of it. Its exponents

have no reservations about placing Bach and Handel alongside each other in a way that no literary historian nowadays would dare with Goethe and Schiller. Any musician who understands their profession perceives the compositional distance between them; as Schoenberg put it, Mozart felt obliged to cut metres of sequences from Handel's *Messiah* for his arrangement of the piece. Music historians, despite claiming to be interested in artistic content, do not acknowledge that distance because of a value-free scientific mindset. They unquestioningly prefer the pleasantly audience-like conventional view, which peacefully subsumes the two composers under the same stylistic period as diametrically opposed exponents thereof. With the same ingenuousness, Bach and Schütz are mentioned in the same breath. Obliviousness to qualities permits an adaptation to the least resistance among ideologically faithful listeners, the consumers of Baroque bestsellers on the record market. Musical factories like Telemann's blur together with Bach, who was less popular in his lifetime. If only to counteract the decline of musical discernment, which inevitably leads to the barbarization of listening, it is time to point out the ideological misuse of the Baroque.

Objections to historicism must go further than the old objections to the sterility in presentations of the once-live spirit as dead property. The more historicism claims custodianship of artistic practice, especially in music, the more starkly it contradicts what it seeks to restore. The assertion that, even though progress does not move in a straight line, what is historically past earned its downfall through its own flaws and cannot be restored at will, least of all out of the need for a spiritual cosmos whose canopy was detonated by the resurgence of productive force, is not an ideologically general historico-philosophical thesis. The irretrievability of all things past and overthrown assumes concrete form in the absurdity of restorative attempts in the face of their object. The legitimate relation to authentic art works of the past is distance, the awareness of their

unattainability, not the empathy that gropes for and exuberantly desecrates them. This unmistakably befalls supposed Baroque music through historical performance practice. Music historians have stumbled on the fact, and confirmed it in some of their recent publications, that orchestration as understood since the nineteenth century did not yet exist at the time. What one calls the Baroque sound did not pass through the compositional subject; it does not obey an imagination that treated colour as a compositional resource in its own right. Rather, that sound was the result of what was available, and in that sense certainly historically necessitated, but arbitrary in relation to the individual work. The instrumental diversity that attracts some people to the period did not emerge from the idea of a scale of musical colours, but from the extra-musical state of an almost anarchic instrument-building technology. The multiplicity of instruments and instrumental types decreased with the critical rationalization that began in the same period, namely tempered tuning. The tone colours revived with gusto are dreary and meagre, and have been made obsolete by purer and more luminous ones. They were by no means crucial to the music of their time in the same way as valve horns or the clarinet family were to the orchestra of the nineteenth and twentieth century. That Bach only stipulated the means of instrumental realization partially or not at all for two of his most mature works, *The Musical Offering* and *The Art of Fugue*, is the most obvious expression of this. It is permissible to speculate whether this notation as 'music per se', which is such a headache for modern performance practice, may actually have sprung from the critical awareness of the genius that what he imagined could not be realized by the sonic means that were available to him—a problem that recent composers searching for 'ideograms' are once again encountering. Given this state of affairs, it would be nonsense to perform music from the seventeenth and early eighteenth century with the customary instrumentation of the time. The freedom for

harmonic improvisation afforded by the continuo principle already disproves the notion that there was anything binding about the typical sonorities in figured bass music. Historical authenticity is of little use when the idea of defined, authentic composition is not yet fully established. In the name of fidelity to the work, one involuntarily enters the same sphere of fancy dress and floodlit festival music that one rails against for its Romanticism, only coming from the other extreme. Such purported fidelity turns into infidelity when it conceals and withholds what it thinks it is reproducing purely: those structural aspects that the art historians defined as the essence of the visual Baroque, and on which compositional quality depends. The respectful boredom that provides so much masochistic delectation today has an objective cause. Baroquified performance ensures that what happens within the music itself—its veins, its subcutaneous layer—remains inaudible. The only relevant interpretations of Bach now would be those that make the specific composed work, the latent motivic connections extending to the tiniest detail, evident to the same degree that, according to Riegl, the structive elements in great Baroque visual art determine its appearance and are present in it. The chaste argument that those structive elements must function on their own, that interpretation must not expose them, but rather allow the musical phenomenon to speak in a state cleansed of all interpretive nuances, is deceptive. The idiomatic, language-like side of all tonal music—and scarcely any music has been determined by tonality as much as that of the figured bass period, whose system of signs is after all an abbreviation of the tonal order—calls for language-like articulation or, as Kolisch calls it, punctuation. Structural music-making, culminating in new orchestrations such as Webern's of the six-part ricercata, eliminates the superstitious belief in appearance that is neatly separate from essence. Anyone who merely uses the phrasing deemed indispensable by the best harpsichordists today signs a contract that demands no less than

violating the boundary of those exercises that is drawn by the ideal of imitating the old practices—which, on top of everything else, is also a fiction. If only the appearance of music were reproduced, without any structive clarification, the result would be gibberish, the prototype of what was once described quite well by the word 'unmusical'. Performing the great music of the seventeenth and eighteenth century adequately, that is, in accordance with its own meaning, amounts to using its own power to shatter all that is mere style about it. Only then would the misuse of style be deservedly avenged.

When the Baroque was rediscovered, at the same time as the incipient art nouveau, it was claimed to be the 'precursor of modern art', as Riegl puts it. After more than half a century, it has turned into the opposite: the ruinous fantasy of an intact world. Therefore, the categories of subjectivity and objectivity for that period are once again open to critique. The rather empty formula of contrast as the Baroque principle is not a licence to make simplistic contradictory statements about the Baroque, for example that on the one hand, subjectivity has grown stronger in relation to the formal canon, while on the other hand—to use the ghastly formulation of one well-established literary historian—subjectivity had not yet 'had a chance' in German Baroque literature. The crucial question of the Baroque can only be approached by those who refuse to submit to the coarse dichotomy between subjective and objective, or to be palmed off with cautious talk of one hand and the other, but instead recognize the dialectical mediation between both aspects. There is no lack of references to this in musicology. In his fundamental essay on the music of the Baroque, Blume interpreted it as a backlash against the autonomy of the music that came about in the Renaissance; the purely immanent musical fabric was always opposed 'in part by the replication of external models (movements, events, noises etc.) and in part by the expression of inner feelings (emotional states, affects)'.[16] He views imitation and

16 Blume, *Syntagma musicologicum*, p. 80.

the theory of affects as key categories in figured bass music, which is amply supported by the aesthetics of the time and the musical manifestos since Caccini. 'Something that became one of the main elements for developing an affective style,' Blume continues, 'was the consistent application of rhetoric to music.'[17] And thus unquestionably a primarily subjective element: music strives to speak like humans. However, because musical rhetoric follows on from the traditional figures of human speech, the rhetorical aspects are, through the allocation of the individual musical figures, which Blume claims correspond to the concept of the motif, joined by formulaic ones.[18] The subjectification of music was accompanied from the start by its opposite, musical topoi, which then ran through the entirety of Viennese Classicism. In a sense, one could call Viennese Classicism a combination of such formulas, heightened in the most artful fashion and concealed by the semblance of constant becoming, yet kaleidoscopic in character. These formulas did not deviate all too radically from their archetypes in older affect-based music until Romanticism became increasingly sensitive to compositional topoi. The subjectification of music and the spread of a mechanical element in it would then not have come from different sides and joined forces, but are originally two sides of the same coin, just as the extremes of subjectification and reification form a unity in recent philosophy. For Descartes, at the dawn of the seventeenth century, the liberated confidence of the thinking self went together with the coercion of the mechanism. Musical topoi bridged the gap between the affective and tectonic elements. Because, as tokens of the affective, they do violence to it to the same extent as the affects needed them as representatives in the objectified art work, the last successful style bore the scars of failure. What Riegl observed in the visual Baroque, namely the conflict between will as externalization towards

---

17 Blume, *Syntagma musicologicum*, p. 81.

18 See Blume, *Syntagma musicologicum*, p. 81.

objectivity and feeling, the being-for-itself of the subject—in short, the divergence of inside and outside, becomes the antagonistic essence of music too. It conditions the overvalued semblance of its self-enclosed in-itself at the expense of the very subject that provided this self-enclosure; the more firmly joined the surface of the works, the more torn what it conceals. The subject that makes objectivity its concern, and possibly makes the real its product, forgets itself in it. The product confronts the subject in a solidified, emancipated, fetishized state. The objectivity of the self-made obscures the fact that it is merely self-made. Rationality, for its part, of the kind that dominates knowledge in the new age, interprets itself as a law that follows the criteria of the necessary and universal and, with them, becomes estranged from the living subject and oppresses it. This process is not one of isolated philosophical reflection, but extends into the foundational layer of the social relations of production, and thus the historical experiences of humanity. It also pervades art; it is simply less obvious there, for art counters the world objectified by the subject with the image of immediate life. The subject, which, groping for its bourgeois autonomy, strives for self-utterance and shatters the predetermined objective idiom in order to be capable thereof, requires such a medium in order to communicate, yet is as little in possession of a language of freedom as it is truly free. It must first create the medium, or simulate it through the rationality that enabled bourgeois emancipation and was meant to fill the vacuum left by bourgeois emancipation with the fall of the medieval *ordo*. This condemns the new idiom to the character of something posited from without, rigid and rickety, that has afflicted musical topoi since the seventeenth century; getting rid of it has been the work of musical progress ever since. The objectivity that so many find comforting in Baroque music was a performance, and always already deceptive. The collective tendency towards it may be explained by the fact that in the current state of consciousness, namely a nominalism

heightened to the extreme over three centuries, such fundamentally usurpatory objectivity has become a secret and disastrous ideal for humans, politically too. In Baroque music, they respond to the primal phenomenon of the order of things that is interlocked with the subjectification process; in the end, this order grins back at them triumphantly from the administered world, which the Baroque justifies to them as an intact figure from bygone times, and they borrow its aura of meaning. The bulky or purring motifs that assuage regressive longing are formulas of a collective agreement that, by its own principle, disavows the binding quality they proclaim. In this sense, the concept of a heteronomy of Baroque music introduced by Blume points beyond what is meant in practice; it must be critically adapted. The Baroque is misused by anyone who chooses this heteronomy out of autonomy, who chooses unfreedom out of a half-true freedom that no one really trusts. The ornament fell victim as much to the critical aesthetic consciousness as to the disenchantment of the world. Human consciousness, already weakened, seeks to accept that world: disenchanted, it remained a material world of commodities. In this context, the Baroque stands for the repressed and longed-for ornament and, as the style that allows and demands it, promises a clear conscience. Yet the supposedly undamaged ornament to which people flee is an expression of the very principle from which they are fleeing. The unity of the bourgeois and the absolutist that draws them to the Baroque stands before their eyes as a metaphor for the deadly order in which the interwovenness of bourgeois society changes into total oppression.

# Vienna, after Easter 1967

*For Lotte Tobisch von Labotýn*

Viennese melancholy in 1967: the fact that there is no more Viennese melancholy. One feels this most clearly in the Prater. It has truly lost its fragrance, and it is not easy to say why. Perhaps because what happened to it in the war did not heal, any more than in the Berlin Tiergarten; a feeling of deforestation remains, even though the trees are growing back. Perhaps one can also blame the fact that the paths were asphalted, as in New York's Central Park, despite the fact that even the main one is closed to cars. The Prater was a kind of Bois de Boulogne. Now that one no longer feels the ground give way, the trace of forest that contributed to its happiness is erased. The fact that the time of the Prater has passed no longer adds to its expression, but rather belies it. It was convincingly explained to me that the asphalt saves money; the staff who look after the paths could not be paid otherwise. On trees one reads the curially roundabout warning of falling branches that might threaten walkers during storms, as if the Prater were lying in wait for disaster. It was only on the drive back on the old-fashioned autobus that brought back the feeling of the familiar city. It had been violently interrupted precisely where it once joined tenderly with nature.

L. recounts how, in Sacré-Cœur at the age of seven or eight, she wrote messily, getting ink blots on her exercise books. The sister who

was teaching admonished her: 'If you carry on like that, the dear Lord Jesus will be offended.' She replied, 'that can't be helped', and was consequently removed from the pious school. But she alone gave expression to Viennese metaphysics as a perfect echo. She doubted neither the dear Lord Jesus nor the fact that He was concerned about the tidiness of her exercise book. But she imagined a higher order above the Catholic one, impenetrably hierarchical, an indomitable Viennese *moira* of nonchalance. Fatality beyond divinity controls existence. Scepticism does not undermine the absolute, but is rather enthroned as an absolute. The course of the world is as incorrigible as locked government offices; all must bow before it.

This nonchalance, which offers consolation for the tenseness and, to quote Mörike, 'veryness' of the German working world, also has a dark side, something of an identification with evil, the undertone that it simply was not meant to be. In Vienna, even among delicate, sensitive and recalcitrant intellectuals, one can observe how people accept the death of a beloved person, for which nonchalance is more to blame than one would like, all too readily. Valentin, who puts down his wood plane when the allegorical Grim Reaper speaks sensibly to him, is equally sensible about another's death.[1] Submission to the inevitable becomes a recommendation thereof, and it is not far from there to schadenfreude. This may explain the delight in the macabre displayed not only by the Viennese spirit, but also with gusto in the city itself, as a counterpoint to cheerfulness. Those who do not take things so hard are happy to let hard things take their course; the city's objective spirit is inexhaustibly productive in this regard. The lad who stabbed a ballet student to death undisturbed

---

1 A reference to the Viennese folk song 'Hobellied' [Wood Plane Song], which appears in Ferdinand Raimund's 1834 play *Der Verschwender* [The Wastrel] and is sung by Valentin, a carpenter. [Trans.]

in the labyrinth of the opera house a few years ago was called Weinwurm.[2]

At the command 'Fetch bitey, fetch bitey!', the well-fed and enthusiastic Boxer named Dagobert leaps wildly away, takes his muzzle between his teeth and brings it to his beautiful mistress. A precursor of voluntary self-control, albeit without enlisting theologians for the purpose.

Went to *The Bartered Bride* on 31 March. Irmgard Seefried, the greatest soprano of her generation in her vocal type, sang Marie. Her children were in the neighbouring lodge; I admired them a little, for they could admire their mother's incomparable art on the stage. The conductor had a Czech name; not as authentic as I would have expected, and especially lacking in the ability to linger that is sometimes required as a contrast to the *brio*, as in the *allegro moderato* quartet in the first act. What makes this music original is the proportion between melody and harmony. The melodies must mirror the chords, while the harmonies must unfold in such a way that they gain perspective over time. Only thus can intimacy articulate itself: in *The Bartered Bride*, shackled subjectivity movingly awakens and hesitantly gains power of itself. The intimacy of early morning is so great that one forgets about the folklorically coarse mockery of the clumsy rival Wenzel. The decorations were naturalistic; I am not ashamed to admit that I liked them. The village scenes knew the secret of the stage decorations as a form: bringing something yearningly distant as close as if one were inside it, without reducing the scent of distance.

---

2 'Wine worm', or potentially also 'crying worm'. [Trans.]

It is strange; the most beautiful number in the whole opera, the *lento* ensemble 'Noch ein Weilchen, Marie, bedenk es dir' [Think on it a little longer, Marie], which protects her from the folly of an arranged marriage and ends with her voice passionately soaring above those of her relatives—in every performance I have ever seen, this master-piece falls short of the musical imagination. It should be sung in a completely transparent, crystalline, almost inanimate fashion, allow-ing the soulful voice to break away. L. undoubtedly explained what was unsatisfactory correctly: to achieve that effect in the vocal ensemble, which is only sparingly supported by instruments, one must cast the most excellent soloists in the supporting roles too, which is prevented by financial considerations. One then finds one-self in the midst of the difficulties that are faced by the musical reper-toire theatre of today, even where it is defended most sincerely.

We lived a few minutes from the opera—in the middle of the city, as it were, but in a park that filtered the street noise into no more than a distant roar, turning the cars into a sound of nature that helped us to sleep. One could go for a walk in the park, ambling past ponds and damaged Rococo gods that looked as if they had come from *fête galante* paintings, and take the steps to the different levels of the grounds. Dry branches were being burned. The wall that finally calls a halt separates the park from the Belvedere Garden. In an outbuilding that may once have held machines and now houses government offices of some kind, there is a little green door. The lady who had invited us revealed that the door opens on a corridor that leads directly to the street, considerably shortening the walk to her home. One could have exactly the same impression in a description by Proust of Faubourg Saint-Germain. If there was one thing he was right about, it was the aim that his book should be the autobiography of every person.

From sociology, one knows the phenomenon of personalization: the widespread tendency to make alienated and hardened conditions and opaque political processes conform to our need for living experience, seemingly, by explaining them with the behaviour of individuals and keeping to them. The common suggestion at American elections that one should choose the best man for president is the prototype of this tendency; it is also followed by the custom in glossy magazines to afford some celebrities or other, who have no bearing on the actual fate of humanity, a publicity which pretends that God knows what depends on these inflated figures and their private affairs, something the consumers do not even entirely believe. This culminates in the so-called personality cult of dictatorships. It is, however, nothing but the reprise of a pre-bourgeois, and in particular an absolutist way of thinking that came from centuries in which the direct will of dynasts corresponded far more to the fate of peoples than in a socialized society whose functional character, namely universal mediation, reduces even those in command to puppets. In Shakespeare, an English king may refer to himself as England. How far the present custom of personalization constitutes the return of a pre-bourgeois phenomenon can be learnt by dealing with feudal persons for whom long-dead heroes from world history are relatives one can converse about, with a little criticism and much leniency, as if world history were actually family history. At times, a favourable light is cast on figures who have a bad name in the historical record; they are credited with good intentions, harmlessness or naiveté—and probably not even wrongly. Some who are traditionally considered dark figures may actually have been good-willed in private. The fact that they were condemned, not the historical tendency, is itself a form of personalization that is legitimately resisted by a closer knowledge of the person and their circumstances. The bourgeois consciousness is especially sensitive to this; it is precisely because so little has depended on individuals since then, even the

rulers, that these must be the guilty subjects of history: they conceal the guilt of history, namely, that it still lacks a subject to this day.

Went to see *Wozzeck* on 9 April. A very fine performance, with Berry as Wozzeck and Christa Ludwig as Marie. Musically very warm and vital, with the tone of Böhm, preserved with great affection and expertise by the conductor Hollreiser. Perhaps not everything was performed as transparently as one can present Berg's music today, so that even highly complex situations can be understood as meaningfully organized. But the rendition spoke the Bergian idiom, an Austrian idiom that carries the specific humanity of that music. One needs to have the musical dialect of *Wozzeck* in one's ear in order to bring out certain expressive characters, such as the unspeakable sorrow of the slow Ländler introduction to the major tavern scene in the second act. Outstanding sets by Caspar Neher. They achieved a complete pragmatic lucidity, the clearest relationship between the visual and musical processes in an atmosphere that far exceeds realism and guides the viewer towards the genuinely musical dimension. Endless applause, like after a repertoire opera. Without making the slightest concessions, *Wozzeck* refutes the claim that New Music is remote from the audience through its sheer artistic self-evidence. This claim is already parroted in advance by biased parties who do not understand the music themselves.

An invitation from an extremely likeable Italian diplomat to a very small private gathering. We were received in a dream of a room. Not a dream in the sense of the effusive expression, but quite literally the kind of room I keep seeing in dreams as a child's image of longing, without ever desiring it in waking life: large, covered completely in red silk, slightly dim, bringing together everything that was driven out by objectivity and fled to the unconscious; a nobleness that one concocts in one's fantasies but is never fulfilled by the world, not

even the grown-up one. The conversation was integrated seamlessly into this. One must age so that childhood, and the dreams it left behind, can be fulfilled—too late.

In the tradition of theatre, especially comedy, it was popular until the time of Hofmannsthal to set scenes or entire acts in taverns, and later hotels, because there all manner of people, including those from very different social circles, could meet and converse without any overt act of dramaturgical violence. The trick is too obvious for a writer attuned to the current moment to continue using it so easily. In the city of Vienna, however, the aesthetic reproduction of itself, a reality of this kind has outlived the comedic technique that was derived from it, and teaches us that social forms from the past hide in artistic conventions. At Hotel Sacher—at Sacher's, as they say— with its waiting rooms, bars and restaurants, the type of communication that normally only seems natural on stage easily arises among the *habitués* and those who know them. The hotel is a kind of great headquarters, but an appointment is not always needed: coincidence and intent merge imperceptibly. It is rare to have dinner there without greeting acquaintances, or without one's companions—after the opera, for example—doing so. It is similar at Hotel Wiesler in Graz. Admittedly, the proverbial 'we' is subject to a general clause, namely that one belongs to the aristocracy or has dealings with it. It is also reflected in the behaviour of the staff, who will indulge a lady bearing a grand name if she wears a woollen jacket or dispenses with stockings, disrupting the ritual performed for her sake. In Vienna, humanity, immediacy and easy social interactions prove to be tied to feudal-hierarchical structures, invisible boundaries, while in bourgeois society, which wants nothing more to do with such boundaries, coldness and indifference between the anonymous triumph for that very reason. There is little more seductive and nothing more dangerous in Vienna: the attraction of the ideology

that the coachman and the count form a community because, like Tamino and Papageno, they both have an established place in the little world theatre that saves them from alienation, yet rests on their unquestioning acceptance.

Of all the arguments spawned by the rancour towards defiant intellectuals, the most idiotic is surely that there is a discrepancy between their mentality and their aristocratic milieu. It has been directed at Proust and Hofmannsthal, whose opponents Kraus rages against, and every provincial critic in the era of expressionism felt terribly witty if they pointed out to Sternheim,[3] who wrote *The Snob*, that he was one himself. What draws some people to aristocrats and some aristocrats to intellectuals is almost tautologically simple: the fact that they are not citizens. The way they live their lives is not fully determined by the exchange principle, and the special ones among them maintain a far greater freedom from the constraint of purposes and practical advantage than others; their practical efforts are rarely successful. Yet one factor in the attraction emanating from this sphere is probably that they no longer exercise political power and rarely have economic power; hence the attraction is quite independent of wealth or poverty. What was once power is absolved of guilt in the image of the name, and of a behaviour that preserves the *désinvolture*[4] of power without the brusqueness of commands, entirely devoid of the ghastly cleverness that asks what advantage and profit one can gain from people—the reflex of a norm whereby acquisition is dishonest or shameful. Once they have made themselves accessible, one can discover in them a caring, almost maternal quality that one scarcely finds anywhere else; no one is easier to deal

---

3 Carl Sternheim (1878–1942) was a German playwright and author of short stories. [Trans.]

4 French for 'unabashedness'. [Trans.]

with and freer from psychological poison; this is a comfort in phase of depression, like the recollection of something once familiar but long lost. The innermost cause of this, however, is an element of defencelessness and helplessness, an inability to find one's bearings entirely. It creates an unspoken solidarity. I told one lady that someone should invent a nature reserve for her, or at least hold a bell jar over her; she received the words with smiling consent.

An outing to Vorderbrühl: a delightful little Liechtenstein castle. One traces an arc, so wide that I did not notice it at first, and just when one thinks one is far away, one suddenly find oneself at the start again. There is a large country inn there, well-heated on that cool spring day. The interior has creaky wooden floors and is slightly dilapidated—like a *Pawlatsche*,[5] as the locals call it. But the food was delicious. Among the charms of Austria that keep driving me there irresistibly, a significant one is that the countryside, and already in the environs of the capital, feels like the southern Germany of my childhood. As one grows older, food and drink become less of a present enjoyment than the hunt for a trace of memory, the chimerical hope that past life could be recreated.

In the Danube floodplain on a working day. A baffling loneliness by the river, only a few kilometres from Vienna. People are kept away from the landscape and flora, which already have an eastern character, by a Puszta-like spell, as if this infinitely open space did not wish to be disturbed. An Austrian statesman from the nineteenth century once said, 'Asia begins east of the Rennweg'.[6] Industries also seem to hesitate. The untouched character of the region would be

---

5 A colloquial Austrian term for wooden arcades allowing access to upper floors of a building. [Trans.]

6 The Rennweg ('racecourse') is a street in Vienna. [Trans.]

archaic if the Romans had not left traces, and if the last German villages had not ventured as far as the Slovakian and Hungarian borders. Beautiful palaces like Niederwalden and Schloss Hof, both undergoing renovation, defy the historical abandonment of the place. The garden of one is closed to the street and strewn with fragments of statues and stone decorations: the eighteenth century as antiquity. From many points one can see Bratislava Castle, where the big road curves past like the one in front of Kafka's castle. One of the localities is Aspern; gazing across the floodplain from the Braunsberg, even someone without any military talent feels like a commander, for the expansive terrain seems so obviously made for the battles repeatedly waged there. The village name Petronell recalls Petronius, but also a non-existent spice. Where the Fischa joins the Danube lies Fischamend, which has a famous fish restaurant and inn with a homeliness that one only feels at the end of the world.

# Art and the Arts

In recent developments, the boundaries between art genres have become blurred—or, more precisely, their demarcation lines are fraying. Musical techniques have obviously been stimulated by painting techniques such as the so-called informalist approach, but also by constructions in the vein of Mondrian. Much music tends towards graphic art in its notation, which not only resembles autonomous graphic shapes; rather, its graphic nature gains a degree of independence from the composed work. This is perhaps most obvious in the works of the Italian composer Sylvano Bussotti, who was a graphic artist before he switched to music. Specific musical techniques like serialism have, as principles of construction, influenced modern prose, such as that of Hans G. Helms, offering compensation for the receding of narrative content. Painting is no longer willing to content itself with the surface. While it has renounced the illusion of spatial perspective, it now urges into space itself, as in the work of Nesch or the proliferating structures of Bernard Schultze. In Calder's mobiles, sculpture, no longer imitating movement as it did in its impressionist phase, ceases to rest quietly in all its parts and instead, following the chance principle of the Aeolian harp, seeks at least to attain a temporalization that is particular to it. Through exchangeability or changing dispositions of material, on the other hand, sections of music become less binding in their temporal sequence and relinquish their similarity with causal relationships. Nor do sculptors any longer respect the boundary

between sculpture and architecture, which would seem self-evident based on the difference between the purpose-bound and the purpose-free; Fritz Wotruba recently pointed out to me that some of his sculptures, in a process that begins from rudiments of the human form, become almost architectural structures—he referred expressly to Scharoun—through progressive de-objectification. I note down such phenomena as one who is accustomed to relating aesthetic experiences to the domain most familiar to him, namely music, with the wilfulness of something that has just been observed; it is not my task to classify it. But it shows itself so frequently and insistently that one would have to blind oneself in order not to see symptoms of a powerful tendency. One must understand it, and possibly interpret the fraying process.

This process is most powerful where it emerges immanently, from the art form itself. One need not deny that some people flirt with one side or the other; if compositions borrow titles from Klee, one suspects them to be of a decorative nature, the opposite of that modernity to which they attach themselves through their designation. Yet such inclinations are hardly as disreputable as the customary outrage over alleged snobbery would suggest. It is those who have reached a standstill that rail most against fellow travellers; in reality, the people they mean have travelled ahead. Immunity to the zeitgeist is no virtue. It usually expresses provincialism, not resistance; even in the weakly guise of imitation, the urge to be modern still contains a modicum of productive power. Yet the fraying tendency is more than mere pandering, or the type of dubious synthesis whose traces alarm us in the word *Gesamtkunstwerk*; happenings only want to be total artworks as total anti-artworks. Thus the dabs of individual sonic elements in music, strikingly reminiscent of painting procedures, can be traced to the principle of *Klangfarbenmelodie*, the incorporation of timbre as a constitutive element, rather than viewed as an imitation of painterly effects.

Webern wrote pieces made of musical dots almost 60 years ago as a critique of that useless spinning-out which so easily feigns eventfulness through mere musical extension. And the graphic notations whose invention shows an entirely legitimate component of playfulness meet the need to capture musical events more flexibly, and thus more precisely than with the usual symbols, which are calibrated to tonality; conversely, they sometimes also seek to create space for improvisatory renditions. In all these cases, then, the works follow purely musical desiderata. It should not be overly difficult to identify similar immanent motivations in most fraying phenomena. If I am not mistaken, those who spatialize painting are searching for an equivalent to the form-organizing principle that was lost when painting lost its spatial perspective. Analogously, musical innovations that disregard what is selectively intended as music in the language of tradition were caused by the loss of the dimension of harmonic depth and the accompanying types of forms. The impetus that tears down the fence posts between art forms is driven by historical forces that awoke within those boundaries and ultimately overflow them.

This process probably plays a considerable part in the antagonism between advanced contemporary art and the so-called general public. Where boundaries are transgressed, a defensive fear of mixture easily arises. This complex is pathogenically expressed in the National Socialist cult of racial purity and the denigration of hybridity. Whatever does not hew to established zones is considered blasphemous and decadent, even though these zones are of historical, not natural origin, some of them as late as the ultimate emancipation of sculpture from architecture, two disciplines that had come together once more in the Baroque. The normal form of resistance to developments supposedly irreconcilable with the genre in which they occur is familiar to the musician as the question, 'Is that still music?' It had long been a refrain while music was still unfolding

according to undoubtedly immanent, albeit modified inner laws. Today, the avant-garde takes the narrow-minded question 'Is that still . . . ?' at its word, sometimes answering it with a music that indeed no longer aims to be such. One string quartet by the Italian composer Franco Donatoni, for example, is put together purely from noises produced by the four stringed instruments. György Ligeti's very important, highly crafted *Atmosphères* no longer knows any individual notes that can be distinguished in the usual sense. *Ionisation* by Edgar Varèse, written decades ago, was a precursor to such endeavours—a precursor because, despite the almost complete absence of fixed pitches, the rhythmic approach still resulted in a relatively traditional musical impression. Art forms seem to delight in a kind of promiscuity that violates civilizational taboos.

Although the blurring of neatly arranged classes of art raises civilizational fears, the trend inserts itself, though the fearful cannot perceive it, into the rational and civilizing tendency in which art has always partaken. In 1938 a senior lecturer at the University of Graz, Othmar Serzinger, published a book entitled *Basics of the Psychology of Art*, which he dedicated to the 'friends of the arts'. The touching philistinism of the plural casts light on the matter: a multitude of goods exhibited for the contemplative observer, from the kitchen to the salon, that are indeed surveyed and sampled in the book. The impatience of art with such multiplicity is understandable when one recalls the funeral platitude that a wealthy deceased man was a friend and patron of the arts. This cliché frequently accompanies the equally ghastly notion of art appreciation, which celebrates its pitiful orgies of stubborn repetition in Sterzinger's domain. Art wants no more to do with its sophisticated friends than is materially unavoidable; when a film mogul in Hollywood sought to compliment Schoenberg on his music, which he had not heard, the composer muttered, 'My music is not lovely'. Art abjures its culinary aspect, which became reconcilable with the spiritual one when it lost its

innocence, its unity with what is composed; the latter had taken on the function of euphony in the progressive control over the material. Since the culinary, the sensual stimulus, split off to become an end in itself and is now rationally planned, art has revolted against any dependence on predetermined materials that resist autonomous shaping, a dependence that is reflected in the classification of art according to the individual arts; for the scattered materials correspond to the diffuse elements of sensual stimulation.

The great philosophers, Hegel and Schopenhauer each in their own way, laboured at heterogeneous multiplicity and sought to synthesize it theoretically—Schopenhauer in a hierarchical system crowned by music, Hegel in a historical-dialectical one whose highest form was meant to be literature. Both were inadequate. Clearly, the quality of works of art does not adhere to the scales of values defining the systems of their different genres. It depends neither on the position of the genre in the hierarchy nor—and Hegel, the classicist, presumably knew better than to claim this—on its position in the development process in such a way that what is later is *eo ipso* better. As a general assumption, this would be as false as its opposite. The philosophical synthesis in an idea of art that transcends the disorganized coexistence of its different genres condemned itself through judgements that flowed from it, such as Hegel's on music, or the verdict with which Schopenhauer reserved a niche for historical paintings. On the other hand, the law of motion in art itself approaches such a synthesis. Kandinsky was the first to note this in his book *Concerning the Spiritual in art*, whose title, for better or worse, encapsulated the latent programme of the expressionists. It is no coincidence that there, a symbiosis of the arts or their agglomeration to create a purportedly heightened effect is replaced by technical reciprocity.

However, the triumph of spiritualization in art, which Hegel anticipated in the construction of what he called the 'Romantic' work

of art, was as much a Pyrrhic victory as a triumph. The grand conception of Kandinsky's manifesto does not shy away from apocryphal evidence, stooping as far as Rudolf Steiner and the fraud Blavatzky.[1] To justify his idea of the spiritual in art, he welcomes anything that invoked spirit against positivism back then—even the spirits. This is not due only to the artist's theoretical disorientation; more than a few in the profession felt and still feel the need for theoretical apologetics. The loss of self-evident truth in their subject matter and technical approaches leads them to engage in reflections they do not always master. With indiscriminate half-education, they take whatever they can get. It is not a matter of subjective inadequacies of thought, however; as faithfully as Kandinsky's text captures the experience of its moment, the actual content of this experience has questionable as well as truthful elements. This forced him to underpin it with more that is questionable. Spirit that is no longer content with the sensual appearance of art takes on a life of its own. Today as much as 50 years ago, anyone can recognize the necessity of this in the inner voices that say 'this is no longer possible' as soon as they encounter sensually agreeable works of art, even if they are authentic. Yet this legitimate and inescapable attainment of independence almost inevitably places spirit in opposition to the materials and procedures of the works as something separate—Hegel would have called it abstract. It is inserted into them as it was once inserted into allegories. The question of what sensual elements have spiritual meaning, as with the symbolic value of colours, and what that meaning is, is decided, paradoxically enough, by convention—the very category against which the entire movement of new art revolted most violently. This is confirmed by cross-connections between the early phase of the radical and the decorative arts. Colours, sounds and whatever else that are purportedly meaningful

---

1 Helena Blavatsky (1831–1891) was a Russian occultist and author. She co-founded the Theosophical Society in 1875. [Trans.]

in themselves play a dubious part in this. Those works that devalue the sensual stimulus with good reason still require sensual carriers in order to realize themselves, as Cézanne put it. The more consistently and uncompromisingly they insist on their spiritualization, the more they distance themselves from what is meant to be spiritualized. Their spirit floats overhead, as it were, with a gaping chasm between itself and its carriers. The primacy of the cohesion brought about in the material by the construction principle changes, on account of its control by spirit, into the loss of spirit, of immanent sense. Since then, all art has been plagued by this aporia, the most serious art most painfully. Spiritualization, rational control over procedures, appears to drive out the spirit as the import of the matter itself. What the material sought to spiritualize terminates in the naked material as something merely existent, as, in later developments, some schools—such as that of John Cage in music—expressly demanded. The spirit, which Kandinsky and quite similarly Schoenberg, in his expressionist phase, had advocated as unspoilt, unmetaphorically true—and Schoenberg too did not manage this without theosophy, which could be said to summon the spirit into existence—loses its binding nature, and is therefore glorified for its own sake: 'You must believe in the spirit!'

For this purpose, the individual art forms strive towards concrete generalization, an idea of art as such. This can be shown once again with reference to music. With his integral procedures that encompassed all compositional dimensions, Schoenberg contributed massively to making them uniform. He articulated this formally in the conception of a theory of musical cohesion. All particular aspects of musical work were to be subordinated to it; the theory of composition became that theory for him. The development of music in the last 20 years can be convincingly subsumed under the primacy of cohesion. By following Schoenberg's programme, knowingly or unknowingly, it interfered with what even he had still considered

musical. He virtually standardized all the technical means that had been developed in the objective, as yet unexamined history of music for creating cohesive contexts, in favour of the internally organized work. Confronted with the norm of artistic purposiveness, however, those means expose themselves soon enough as arbitrary and limited—as special cases of musical cohesion as such, just as tonality had revealed itself in his œuvre as a special case among the forms of melodic-harmonic cohesion on which he could draw at times. Now, after Schoenberg, came the unforeseeably far-reaching step of separating the concept of musical cohesion he had attained from its traditional preconditions, and thus from all that had been sedimented under the concept of the musical. Music, having become allergic even to such means of cohesion as free atonality and the 12-note technique, in which its sharpened ears detected the traces of the tonality negated within it, confronted the concept of cohesion, liberated from its previously aurally embodied and limited guises. The entire work of Stockhausen can be understood as an attempt to explore possibilities of musical cohesion in a multi-dimensional continuum. Such mastery, which, in an unforeseeable multiplicity of dimensions, allows the creation of cohesion, connects music from within to the visual domain—to architecture, sculpture and painting. The further the means of cohesion in individual art forms extend beyond their hereditary resources and become formalized, the more the different genres are subordinated to something based on identity.

Admittedly, the demand to unify art forms as art, foreshadowed by the integral procedures within the individual genres, is older than modernity. Robert Schumann coined the saying that the aesthetic of one art is also that of the others. This was Romantic in its intention, with the point that music should ensoul its architectural aspects, which had become offensive in their formulaic character, and become poetic, just as Beethoven was considered a tone poet by the generation that followed him. In contrast to modern fraying, the

emphasis was on subjectivity. The works became imprints of a soul, one not at all identical to the individual composer: the language of the self's free expression. This brought the arts closer together. One could certainly show how similarly ensoulment infuses the different genres; but their boundaries were scarcely weakened by this. They remained what they were, and this discrepancy is not the most insignificant critical motif in recent developments. What is problematic about the primacy of the aesthetic, as something ensouled, over its media can be identified most easily in the characteristic category of mood. From a certain point on, namely the rejection of neo-Romanticism and impressionism, modernity turned against it. Yet what was irksome about mood as an effete and fluid quality was not so much the narcissism of which the reactionary friends of hearty artistic fare accuse anything nuanced, which they are incapable of appreciating, but rather an aspect of the objectivity of the matter: a lack of resistance at the heart of its internal constitution. When a work seeks mood in contourless, self-aggrandizing fashion, it lacks the aspect of otherness. Art requires something heterogeneous to itself in order to become that. Otherwise, the process that each work constitutes in itself, based on its import, would have no point of attack; its inner motion would be empty. The opposition between the work of art and the sphere of objects only becomes productive, and the work only becomes authentic, when it immanently works through this opposition and objectifies itself through that which it consumes within itself. No work of art, not even the most subjective, is fulfilled purely by the subject that constitutes it and its import. Each one has materials that are heterogeneous to the subject, approaches derived as much from the materials as from subjectivity; its truth content does not exhaust itself in these, but rather stems from an objectification that requires the subject as its executor, yet, through the immanent relation to that other, points beyond the subject. This introduces an irreducible, qualitatively manifold element.

It opposes any principle of unity, including that of artistic genres, through the very thing they express. If works of art disregard this, they easily degenerate into the aesthetic as such, which one can see in the products of those who have 'artistic talent', as people say, but not really for anything. It was especially those artists of very high quality whose talent was not tied unambiguously to a single material, such as Wagner, Berg, perhaps also Klee, that justifiably focused their energy on sacrificing the generally aesthetic for the specificity of the material. Nonetheless, the former is preserved as an ether, a form of reaction that does not content itself with the all-too-realistic hardness of the material discipline. While art that satisfies itself with the generally aesthetic gravitates towards amateurism, art that expunges the last trace of that ether—the simple fact that someone is an artist—dries up into technical philistinism. It is no coincidence that the proponents of the folk and youth music movement have often been sorely vexed by Schumann's words. If the aesthetic of uniformity passes all too quickly over the art work's inner heterogeneity—in Schumann's music, this ruinous process turns into an aesthetic quality, an expression of the ominous—then the opposing demand for an adequacy to the material that rolls up its sleeves is self-righteous. It feigns a truth content in the heterogeneous aspects of the art work, especially those practices not filtered through subjectivity, that they do not possess in themselves.

The conflict between art and the arts cannot be resolved through a dictum favouring the one or the other. Even in the late Romantic period, the arts defied the neat standardization—which is exactly what art nouveau was—that was being preached in the name of stylistic will. We know that the relationship of great neo-Romantic writers like George and Hofmannsthal to visual art was a troubled one. They saw symbolist painters like Burne-Jones, Puvis de Chavannes and Böcklin as kindred spirits, and George did not shy away from the Wilhelmine slur referring to 'cheeky dabs of paint' to

describe the impressionists. They failed to see that their poetics was better matched with the techniques of impressionism than with the likes of the subsequently infamous *Consecration at the Mystic Spring*.[2] This was not due to literary eccentricity or a provincial ignorance of what was going on in Paris. There is no shortage of poems by George whose imagery is undeniably close to dire symbolist painting. Because the best of them find their specific vividness in language, not the visual imagination, they become something wholly different. If one translated the autumnal landscapes of the cycle *The Year of the Soul* into painting, they would be kitsch. In their linguistic form, where the words for colours have quite different qualities from the concrete colours in a painting, some of them defy obsolescence. It is these qualities that connect poetry to music. How art forms differ from one another in their essence, their import, when their subject matter and layers of associations are very similar, can be observed most clearly in music. The eccentric flavour of old German ballads, knights in armour or courtly love in Brahms's expressive language can only be denied by those whose musical ability lacks the extra-musical supplement found in all that is musical. However, because those expressive elements in Brahms are neither captured in pictures nor clumsily verbalized, but merely flash up and disappear in an instant, they escape the sphere of crude materiality. No critique could oblige the works to such fleeting expressive ferments; they never stand out awkwardly, in materially crude fashion, from the composed work. Rather, they dissolve in its pure unfolding, a wonderfully internally crafted musical language. This language is inspired by those heterogeneous aspects, but is never reduced to them or their level. If great works of art need luck to become great, Brahms's luck lay in the fact that his ballads became music, not

---

2 A mural for the Museum of Applied Arts in Cologne painted by the German artist Melchior Lechter (1865–1937). It depicts Stefan George receiving a mystical potion on his knees. [Trans.]

poetry. *What* is meant by the arts changes depending on *how* it is meant. Their import is the relationship between the *what* and the *how*. They become art by virtue of their import, which requires their *how*, their particular language; anything more comprehensive outside the genre would dissolve it.

Attempts to establish conclusively whether primacy belongs to art or the arts usually come from cultural conservatives, for their goal is to reduce art to invariants that, modelled openly or latently on the past, serve to defame present and future forms. Conservative, truly reactionary thinking always tends towards a division into sheep and goats, recoiling from the thought of anything objectively contradictory within the phenomena. They brand dialectics heretical, a sophistic sorcery, without the possibility of granting space to its *fundamentum in re*.[3] Yet that most resolute German advocate of a qualitative difference between the arts that makes almost any concept of art impossible, the extremely archaically inclined Rudolf Borchardt, demonstrated profound incomprehension when paying tribute to Hegel in an essay on Benedetto Croce. In the mistaken belief that Hegel only made history beyond academic disputes in the work of Croce, he did not realize that the latter removed the truly dialectical element from Hegel, deeming it dead, and evened it out into the concept of development that was widespread around 1900, a peaceful coexistence of diversity. Borchardt's own intention, laid out in the essay 'The Poet and the Poetic', is not offended by any dialectics. Invoking Herder, he aims to set apart the poetic, as a primal language that transcends the arts, from all art as a 'visionary capacity'. He claims that categories such as untouchability, protection of the gods, exceptionality and sanctification are native to poetry, and

---

3 Latin for 'foundation in the thing', a phrase used in medieval philosophy in opposition to an abstract or imagined foundation. [Trans.]

poetry alone. Tracing a historical arc, Borchardt sketches his outline of an intensifying conflict between the poetic and the profane world. His slogans are irrationalist:

Forget your aesthesis, forget your intelligence: the poetic is not accessible to it. The artistic may be accessible to it. Literature may be. But wherever the poetic appears among you today, it is, as in the days of Solon and Amos, it is an integral in which the law, religion, music and almost even the magic spell appears alongside living lie, an all-in-all, an encyclopedia of the world that is fundamentally different from the scientific encyclopedia of the world.[4]

One cannot resist asking how such an encyclopedic totality can be reconciled with the Borchardtian arcanum. It will, he continues, be

reborn with every poetic ingenuity, from which it derives the wish to take form again and transfer itself to you, as in times past; in the past and future tense, without present. It is a prediction of the future like those of former times, it contains the future like the eternal day of creation—not, as the literati would have it, as a political revolution, but as a return to God for children of God, as in the old days of the poet who carried the wreath and the staff.[5]

Borchardt is aiming for nothing less than the unmetaphorial apotheosis of poetry, to 'allow, with shame and awe, the wondrous things that dwell and houses between them and among them: the divine in its own forms. Await the revelation and do not try to assist its arrival.'[6] That is precisely what, according to Borchardt, happens in

---

4 Rudolf Borchardt, *Prosa*, VOL. 1 (Maria Luise Borchardt ed.) (Stuttgart: Klett-Cotta, 1957), p. 69.

5 Borchardt, *Prosa*, VOL. 1, pp. 69f.

6 Borchardt, *Prosa*, VOL. 1, p. 69.

the other arts, especially the visual. He seeks, with forced naiveté, to put himself

> once more in the position of primordial man, who is faced on the one side by the poet as I have attempted to describe him, and on the other side by the artist, namely the sculptor or the painter. You can observe the latter's trade, how he works, how he moulds and hones what he has moulded, how he draws, and you realize what it is that he is supposedly depicting: he kneads, for example, and you realize what he is kneading in imitation or kneading as a model for something else. Associations arise, first the inference of identity and then aesthetic seeing; the categories of rightness, similarity and beauty. But what matters to me is this: for the naive and original human being, the painter or the sculptor is someone who possesses a craft [ . . . ] and someone whose work, if you stand next to him and watch, is an object of wondrous admiration for the naive observer, of joyful appreciation, but not a mystery; for you see him producing it. With the poet, however, you do not see it. No one has seen it. For the Greek and the primordial human being, the sensual arts lack all the things I have mentioned to you: the mystery, the problem. And even if one were dealing with skills of the highest level, an ever and ever higher level— what you missed was the intoxication, the consciousness of something transcendent. The muse of the visual artists is not a muse, it is *techne*. What is missing is the demonic, the incalculable.[7]

The pathos against the disenchanted and reified world is a little stale. Only someone who wishes once and for all to reduce to craft what once emerged as craft, someone who is blind to the invisible within

---

7 Borchardt, *Prosa*, VOL. 1, pp. 46f.

the visible, can claim that the art forms which arose from craft lacked the highest power, the ability to express the utmost. Visible making does not coincide with the aesthetic truth content, and even the poet might have someone looking over their shoulder as they write. The riddle character, which Borchardt reserves purely for poetry, is inherent in all art that says it, yet does not say what it says. Probably that element which is opposed to instrumental rationality and speaks to us from archaic sculptures was already present in the origin of visual art, in the mimetic faculty; undoubtedly visual art acquired it later, precisely with advances in *techne*. Borchardt's opposition between visual art as *techne* and poetry is unconvincing, for the medium of visual art is also that from which Borchardt seeks to distance it, namely language—to say nothing of the fact that music does not fit into his dichotomous schema at all. On the other hand, the traits he portrays as more narrowly art-like and technical belong equally to poetry, and play a decisive part in its success. It is unimaginable that a linguistic virtuoso like Borchardt, whose case for poetry must have reflected on his own situation, would have overlooked this and attributed everything to inspiration, like an operetta composer who eagerly admires Mozart. He translated Pindar, Dante and, with particular mastery, Swinburne into German. Does he mean to deny the Dorian choral poet's artistry, which, with antique coquetry, he calls philistine? Does he consider the work of the Florentine, replete with realia and allegories, mere intoxication? Does he fail to hear the technical component in Swinburne's music-like verses, which is separated from its material and only thus ultimately masters it? The colossus of poetry conjured up by Borchardt's suggestive power stands on feet of clay. It is a *blague*. The wealth of associations and oppositions sophistically conceals that the subject Bochardt calls the most serious, of which he means to speak as soon as he is taken seriously, defies any attempt to set off the different artistic genres against one another in a conclusive, quasi-ontological sense.

The opposing position to Borchardt in this dispute, that of Martin Heidegger, is certainly no less ontological, though it is more thought-through in that very aspect. Heidegger's elucidations of Hölderlin in fact contain passages that, following on from Hölderlin's own verses, grant the poet as a founder a similar prerogative to that assigned by Borchardt; both were probably influenced in this by the George school. But Heidegger, in keeping with his dominant concept of Being, longs for unity incomparably more than the artist does. His theory that Being is always already in the world and transcends into entities does not allow him to denigrate technology any more than his old metaphysical *parti pris* about craftsmanship, the archetype of readiness-to-hand from *Being and Time*. Whereas Borchardt mixes art and religion, concealing the constitutive element of secularization in the art work, the achievement of Heidegger's text about the origin of the art work in *Off the Beaten Track* lies in its sober definition of the thingness of the object, which, as Heidegger says with justified irony, even the much-cited aesthetic experience cannot evade. Thingness and unity—that of rationality, which admittedly disappears in Heidegger's concept of Being—belong together. But Heidegger takes a step beyond this and makes a claim that is unacceptable for Borchardt, namely that all art is in essence poetry, and that architectural art, visual art and music art can accordingly be traced back to poetry.[8] The arbitrariness of this statement is not lost on him, in so far as it relates to the actual arts, which are—in his language—ontic. He works his way out of this dilemma through an ontologization of the artistic as the 'illuminating projection of the truth'. This is poetry in the broad sense, of which poems are only one facet. Heidegger, unlike the linguistic artist Borchardt, emphatically underlined the linguistic character of all art. Yet this ontologization spirits away what distinguishes the arts from one another, namely

---

**8** Martin Heidegger, *Off the Beaten Track* (Julian Young and Kenneth Haynes trans) (Cambridge: Cambridge University Press, 2002), p. 45.

the relation to their materials, as something subordinate. What remains after this is subtracted is, for all Heidegger's protest, something highly indeterminate. Its indeterminacy communicates itself to Heidegger's metaphysics of art in the form of tautology. The origin of the art work, it is emphatically claimed, is art. Here, origin, as is always the case in Heidegger, is not temporal genesis but the provenance of the essence of art works. His doctrine of such origin adds nothing to what emerged from it, and indeed cannot do so, otherwise it would taint itself with that Dasein which the sublime concept of origin wishes to leave beneath it. Heidegger rescues the aspect of unity in art, that which makes it art, at the cost that theory falls reverently silent when faced with the question of what it is. If it becomes invisible through Borchardt's sleight of hand in the theological sphere, which is the genuinely poetic one, it evaporates into pure insubstantial essentiality in Heidegger. As if under pressure from the multiplicity that revolts against it, the aesthetic aspect of unity shrinks to what Heidegger once said about Being: it is ultimately nothing more than merely itself. Art cannot be distilled either to its pure unity or to the pure diversity of the arts.

What must be abandoned, at any rate, is the naively logical view that art is simply the general term for the arts, a category that contains them as its types. This schema is destroyed by the inhomogeneity of that to which it is applied. The general term disregards not only the accidental, but also the essential. Suffice it to recall that there is an essential difference—at least in historical retrospect—between those art forms that have or had an image character and continue to draw latently from its legacy, that is, the imitative or representative arts on the one hand, and on the other hand, those that reject the image character in advance and only implant it gradually, intermittently and always precariously, such as music. Furthermore, there is a qualitative difference between poetry, which requires concepts and, even in its most radical forms, cannot entirely shake off the

conceptual element, and the non-conceptual art forms. Yet music in particular, as long as it employed the predetermined medium of tonality, contained quasi-conceptual elements, harmonic and melodic markers, the few tonal chord types and their derivatives. Never, however, were they unifying characteristics of something subsumed under them; nor did they 'mean' in the same way a concept means its phenomena; they could only be employed, like concept, as identical elements with an identical function. At any rate, differences like these, with their unfathomable perspectives, show that the so-called arts do not form any continuum among themselves that would allow us to apply an intact, uniform concept to the whole. Perhaps, without knowing it, the arts also fray in order to abolish the difference of name among things that walk under the same name. A comparison to a musical phenomenon and its development may elucidate this: the orchestra does not form a whole that is complete in itself, a continuum of all possible timbres, for there are sensitive gaps between some of these. Certainly, electronics originally sought to provide the orchestra with that missing homogeneity, but it soon became aware of its differences from all traditional sound sources and abandoned the ideal of the integral orchestra. It is impossible to compare the relationship between art and the artists to that between the historically formed orchestra and its instruments without doing violence to it; art no more constitutes the concept of the arts than the orchestra the spectrum of timbres. Nonetheless, there is some truth in the concept of art—just as the idea of the total timbral range inheres in the orchestra as the telos of its development. In relation to the arts, art is something that forms itself,[9] and is thus potentially contained in each individual one of them, in so far as each must strive to liberate itself from the fortuity of its quasi-natural aspects by working

---

9 The phrase 'something that forms itself' is a translation of *ein sich Bildendes*; while the verb *bilden* here means 'to form', it should be noted that *bildende Kunst* is the general term for visual art, and *Bild* means 'image'. [Trans.]

through them. *Such an idea of art within the arts is not positive, however, it is not simply present within them, but can only be grasped as negation.* One can only identify negatively what unites art forms in their content, beyond the empty classificatory term: all of them are repelled by empirical reality, all of them tend towards the formation of a sphere qualitatively opposed to it. Historically speaking, they secularize the magical and sacral sphere. All of them need elements from the same empirical reality from which they distance themselves; and their realizations, after all, are also part of empiricism. This conditions the twofold position of art in relation to its genres. In keeping with its inextinguishable share in empiricism, art only exists in the arts, whose mutually discontinuous relationships are predetermined by extra-artistic empiricism. As an antithesis to empiricism, however, art is one. Its dialectical nature lies in the fact that it can only complete its movement towards unity through plurality; otherwise, the movement would be abstract and powerless. The relation to the empirical layer is essential to art itself. If it omits this, then what it takes for its spirit remains external to it, like some substance; only within the empirical layer does spirit turn into import. The constellation of art and the arts is inherent in art itself. It stretches between two opposing poles: a unifying, rational one and a diffuse mimetic element. Neither of them should be given precedence; art should not be reduced to one of the two, not even to their duality.

However, any view of the transition of the arts into art that did not involve an aspect of the import that is not aesthetic in itself would be too harmless. The history of the new art is largely that of a loss of metaphysical meaning according to an irrevocable logic. As clearly as the artistic genres, based on their own laws of motion, are unwilling to remain in their separate zones, the impulses of the artists, which induce them to adhere to this tendency almost without resistance, are closely intertwined with the loss of meaning. They

make that meaning their cause and turn their own innervation towards this purpose. Whether aesthetic theory finds the word for this or, as is usually the case, lags behind the development with hands thrown up in horror, depends not least on its insight into that aspect of the artistic spirit which sabotages the meaning of art. Certainly, many entrust themselves to a tendency that unburdens them of their own effort, as well as promising a substitute for the security that was shattered by the emancipation of art from its types and schemata throughout modernity. There is an inescapable parallel to the logical positivism that is supplanting philosophy in the Anglo-Saxon world: a complete rejection of all meaning, even the idea of truth itself, evidently creates a sense of absolute, unequivocal certainty, even if this certainty no longer has any content. But that is not all there is to say about the intoxication of insatiable sobriety that is meanwhile referred to with the word 'absurd' as a kind of magic formula: a self-awareness of internal contradiction, of the spirit as the organ of senselessness. The experience of this extends to some phenomena of contemporary mass culture, and it is fruitless to ask what meaning they have, for they rebel against the concept of sense and the assertion that existence is meaningful; not infrequently, there are points of contact between the higher and lower extremes in the aesthetic domain. For millennia, art feigned the supposed meaning of life and hammered it into people's heads; even the origins of modernity, on the threshold of what is currently happening, did not call it into question. The internally meaningful work of art, all its aspects determined by spirit, was the accomplice of what Herbert Marcuse called the affirmative nature of culture. In so far as art was also a form of depiction, its cohesion through its semblance of necessity affirmed the object of depiction as meaningful, whatever tragedy it might experience and however viciously it might be accused of ugliness. The abandonment of aesthetic meaning today thus goes hand in hand with the external and internal

representationality. The fraying of the arts, which is hostile to an ideal of harmony that presupposes an orderly arrangement among the genres as a guarantor of meaning, seeks to escape from the ideological confinement of art, which extends to its constitution as art as an autarkic sphere of the spirit. It is as if the artistic genres were gnawing at the concept of art itself by negating their well-defined form. The archetypal phenomenon of the fraying of art was the montage principle, which emerged before the First World War in the cubist explosion and, probably independently thereof, among such experimenters as Schwitters, then in Dadaism and surrealism. But montage amounts to disturbing the meaning of art works through an invasion by fragments of empirical reality that is beyond the laws of that meaning. The fraying of art forms is almost always accompanied by an attempt by the works to reach for extra-aesthetic reality; this act goes strictly against the principle of their depiction. The more a genre allows in of what its immanent continuum does not contain, the more it participates in what is foreign to it and thing-like, instead of imitating it. It turns virtually into a thing among things, into something of which we do not know what it is.

This not-knowing gives expression to something that is inescapable for art: even the loss of meaning, which it adopts as if seeking to destroy itself, or to keep itself alive with an antidote, cannot— even against its own intentions—remain its last word. The non-knowing of the emphatically absurd art work, the Beckettian art work, marks a point of indifference between meaning and its negation; it would be a blasphemy against this indifference, however, to read a positive meaning into it with a sigh of relief. Nonetheless, it is impossible to imagine an art work that, by incorporating the heterogeneous and turning against its own context of meaning, does not form one after all. Metaphysical and aesthetic meaning are not one and the same, even today. The meaningless realia that enter the zones of art works in the fraying process are potentially rescued by

them as meaningful to the same extent that they violate the traditional meaning of the works. Consistent negation of aesthetic meaning would only be possible through the abolition of art. Major recent works are the nightmare of such abolition, even as they resist it through their mere existence; as if the end of art threatened to be the end of a humanity whose suffering calls for art, one that does not smooth over or alleviate it. It dreams humanity's demise for it, so that humanity might awake, retain power over itself and survive.

The negativity of the concept of art affects its content. Its own character, not the powerlessness of ideas over it, forbids any definition of it; its innermost principle, the utopian one, revolts against the nature-controlling principle of definition. It refuses to remain what it once was. How far this is also dynamized by its relationship with its genres can be seen from its latest, the cinema. It is helpless to ask whether film is art or not. On the one hand, as Benjamin was the first to recognize in his essay 'The Work of Art in the Age of Mechanical Reproduction', cinema comes closest to itself when it uncompromisingly exorcises the attribute of aura, which existed in all pre-cinematic art, the semblance of a transcendence guaranteed by the context—or, differently put, when, in a fashion scarcely dreamt of by realistic painting and literature, it dispenses with symbolic elements and those that bestow meaning. Siegfried Kracauer concluded from this that film, as a way of redeeming the extra-aesthetic world of things, is aesthetically possible only through an abandonment of the stylization principle, through the intentionless immersion of the camera in the raw state of the existent that is prior to all subjectivity. But such a *refus*, as a precondition for the crafting of films, is once again a principle of aesthetic stylization. Even with the utmost asceticism towards aura and subjective intention, the cinematic process inevitably instils into the work, for purely technical reasons—through the script, the shape of the filmed figure, the camera angle, the editing—elements that give meaning, much like

those procedures in music or painting that seek to bring out the naked material, yet preform it through this very striving. While film seeks to cast off its artistic character based on its immanent laws—almost as if it went against its artistic principle—it is art even in this rebellion, and expands it. This contradiction, which film cannot exclusively explore on account of its dependence on profit, is the vital principle of all genuinely modern art; the fraying phenomena of the genres are probably secretly inspired by it. In this sense at least, the happenings—ostentatious meaninglessness does not necessarily express or shape the meaninglessness of existence, admittedly—are exemplary. They submit unreservedly to the yearning for art, contrary to its principle of stylization and the latter's kinship with the image character, to become a reality sui generis. It is precisely through this that they inveigh most harshly and shockingly against the same empirical reality whose equals they would be. In their clownish foreignness to the purposes of real life, in whose midst they take place, they are its parody in advance—and they unmistakably embrace this role, as in their parody of the mass media.

The fraying of the arts is a false demise of art. Its inescapable illusory character becomes scandalous in the light of a dominance of economic and political reality that makes a mockery of the very idea of aesthetic semblance, since it no longer allows any view on the realization of aesthetic import. That semblance is becoming increasingly incompatible with the principle of rational control over material, to which it was connected throughout the history of art. While the situation no longer permits art—this was the intention of the statement about the impossibility of poems after Auschwitz—it requires it all the same. For an imageless reality has become the perfect counterpart to the imageless condition in which art would disappear, because the utopia that is encoded in each work of art would have been fulfilled. Art is not capable of such a demise of its own accord; that is why the arts chafe at one another.

# Bibliography

BLUME, Friedrich. *Syntagma musicologicum* (Marin Ruhnke ed.). Kassel, Basel and London: Bärenreiter, 1963.

BORCHARDT, Rudolf. *Prosa*, VOL. 1 (Maria Luise Borchardt ed.). Stuttgart: Klett-Cotta, 1957.

HARTLAUB, Gustav Friedrich. *Fragen an die Kunst*. Stuttgart: K. F. Koehler, 1950.

HEIDEGGER, Martin. *Off the Beaten Track* (Julian Young and Kenneth Haynes trans). Cambridge: Cambridge University Press, 2002.

KIERKEGAARD, Søren. *Repetition and Philosophical Crumbs* (M. G. Piety trans.). Oxford: Oxford University Press, 2009.

KRACAUER, Siegfried. *Theory of Film: The Redemption of Physical Reality*. Princeton, NJ: Princeton University Press, 1997.

LE CORBUSIER. *My Work*. London: The Architectural Press, 1960.

LOOS, Adolf. *Gesammelte Schriften* (Adolf Opel ed.). Vienna: Lesethek, 2010.

MARX, Karl. Letter to Ferdinand Domela Nieuwenhuis (22 February 1881) in *On Revolution*. New York: McGraw-Hill, 1971.

RIEGL, Alois. *The Origins of Baroque Art in Rome* (Andrew Hopkins and Arnold Witte trans and eds). Los Angeles: Getty, 2010.

SILBERMANN, Alphons. 'Kunst' (encyclopedia entry) in René König (ed.), *Soziologie*. Frankfurt: S. Fischer, 1958.